O9-ABH-959

WASHINGTON UNIVERSITY LIBRARIES
ST. LOUIS, MISSOURI 63130

Washington
University in St.Louis

University Libraries

NO LONGER PROPERTY OF
OLIN LIBRARY
⋅⋅ıINGTON UNIVERSITY

Kings
Work of Simon Grennan
er Sperandio

R
GE

THEIR HEARTS BEATING WILDLY, TH
FOUR FRIENDS *SCOOP* UP THEI
PICNIC THINGS AND RUN TO THE
CAR, *TERRIFIED* OF... WHO
KNOWS WHAT.

Kartoon Kings

The Graphic Work of Simon Grennan and Christopher Sperandio

for Colin De Land

Kartoon Kings
The Graphic Work of Simon Grennan and Christopher Sperandio

Published by the West Virginia University Press, Morgantown 26506
for the Division of Art, College of Creative Arts, West Virginia University

© 2007 West Virginia University Press

All rights reserved

First edition published 2007 by West Virginia University Press
Printed in Singapore

15 14 13 12 11 10 09 08 07 9 8 7 6 5 4 3 2 1

ISBN-10 1-933202-24-6
ISBN-13 978-1-933202-24-2
(alk. paper)

Library of Congress Cataloguing-in-Publication Data

Kartoon Kings. The graphic work of Simon Grennan and Christopher
Sperandio. / [edited] by Paul Krainak
 p. cm.
 1. Grennan, Simon—1965-. 2. Sperandio, Christopher—1964-.
3. Public art. I. Title. II. Krainak, Paul. III. Decter, Joshua. III. Olson, Kristina.
IN PROCESS

Library of Congress Control Number: 2007932020

All rights reserved. Permission to reproduce any part of this book, or to
use, for any purpose, any text from this book, should be directed to the
publisher, West Virginia University Press, P.O. Box 6295, Morgantown,
WV 26506-6295. Requests for permission to use, for any purpose, any
artwork or photographs displayed in this book, should be directed to the
artists or their representatives, who can be contacted through the West
Virginia University Division of Art of the College of Creative Arts, P.O. Box
6111, Morgantown, WV 26506-6111.

This publication was made possible by generous funding provided by the
Myers Foundation to the Division of Art in the College of Creative Arts at
West Virginia University.

Designed by Alan Ward /Axis Graphic Design Limited
http://www.axisgraphicdesign.co.uk/

Printed by Craftprint, Singapore

5

The artist team of Simon Grennan and Christopher Sperandio work via the digital pipes of today's Internet - Grennan lives in England and Sperandio lives in the United States.

Since meeting at graduate school in 1988, Chris and Simon have continued to collaborate on community-based drawings, paintings, animations and comic books for museums and art centers internationally. They've averaged three or four large new works each year for diverse venues such as WIRED Magazine, London's Channel Four, DC Comics and The Museum of Modern Art/PS1.

Simon Grennan was born in London, England, and studied sculpture at Reading University and at the University of Illinois, Chicago. Christopher Sperandio was born in Kingwood, West Virginia, and studied art at West Virginia University, and painting at the University of Illinois, Chicago.

Since the mid-90s, they've operated under the umbrella of Kartoon Kings, online at Kartoonkings.com

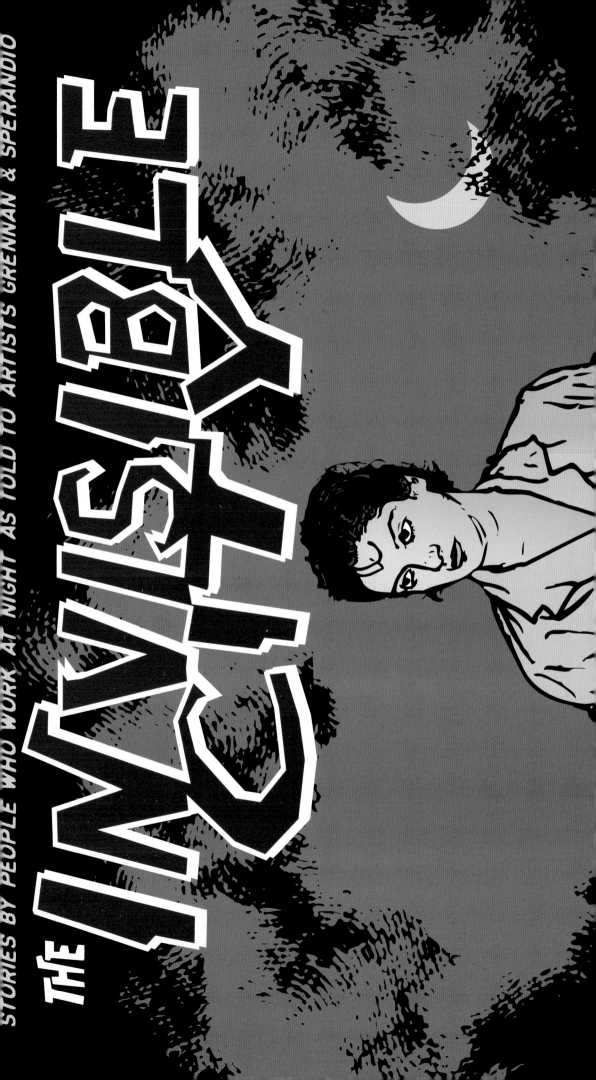

MODERN MASTERS

TALES FROM THE PINNACLE OF CULTURE

STORIES ABOUT PS1 AND THE MUSEUM OF MODERN ART AS TOLD TO ARTISTS GRENNAN & SPERANDIO

"WE'LL BEGIN with a REI
a FEW murders h
MURDERS OF GREAT MEN, murders of
we might even

DERAI

derailed.
AaBbCcDdEeFfGgH

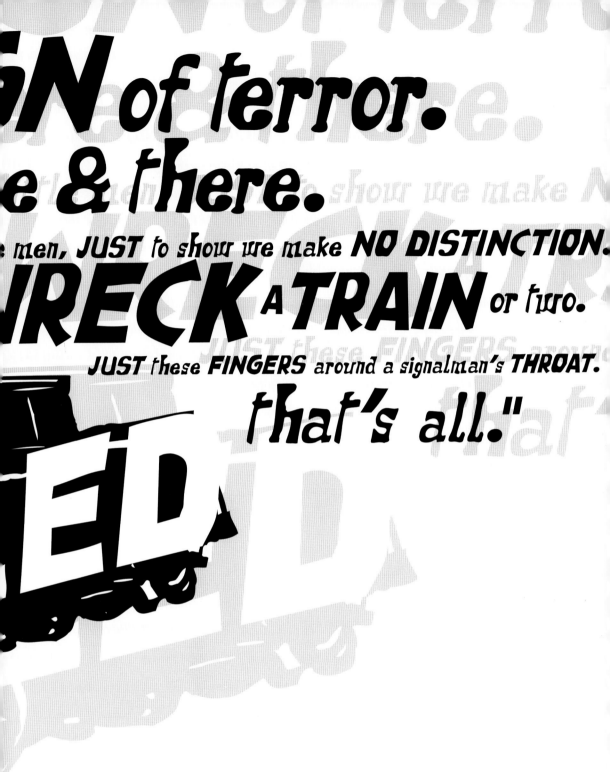

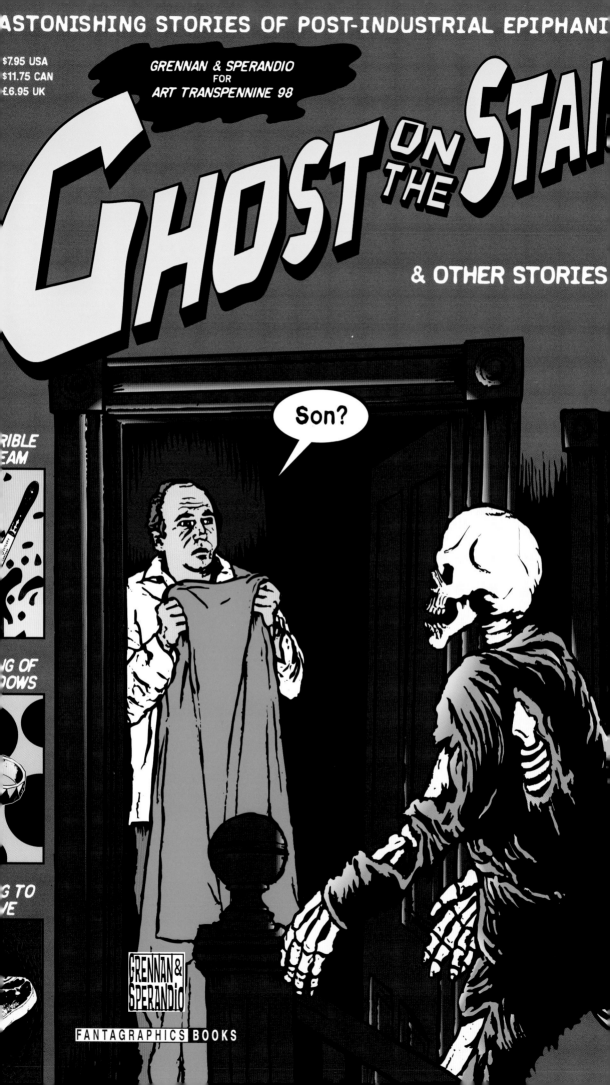

THE HAND AND THE WORD
A NEW ANIMATED FILM BY

kartoon kings .com

WWW.THEHANDANDTHEWORD.COM

COMPILED AND DRAWN BY GRENNAN & SPERANDIO FOR BRIGHTON MUSEUM AND ART GALLERY DE LA WARR PAVILION, BEXHILL-ON-SEA HASTINGS MUSEUM AND ART GALLERY LEWES CASTLE MUSEUM

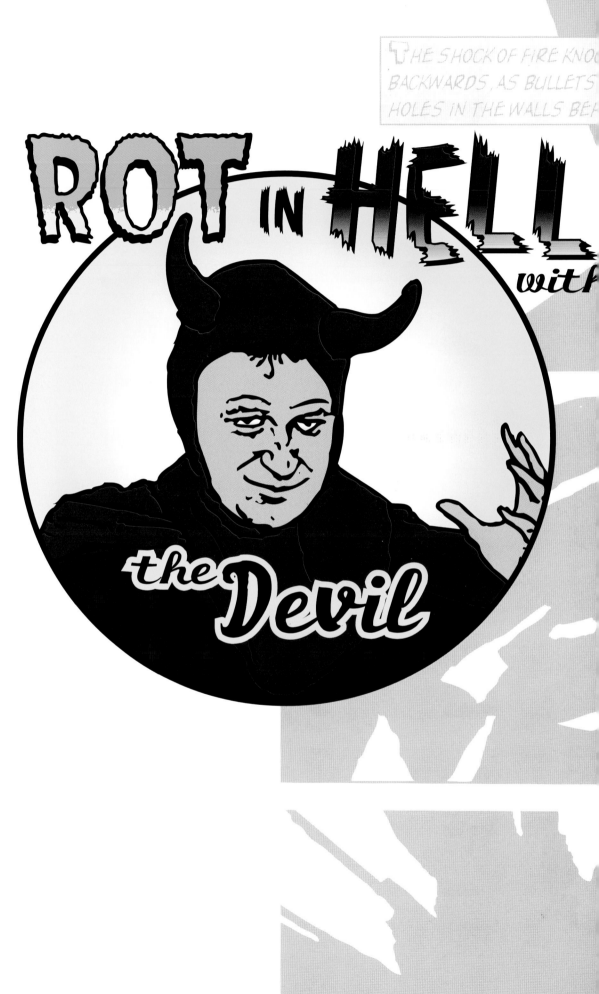

THE SHOCK OF FIRE KNOC
BACKWARDS, AS BULLETS
HOLES IN THE WALLS BEH

Five Sentence Stories by Simon Grennan & Christopher Sperandio

A U.S. BOMBER PILOT RETURNS FROM A DISASTROUS RAID, COMRADES DEAD AND INSTRUMENTS SHOT AWAY.

CLOUD COVER IS THICK AND LOW AT DAWN. LOST AND NOW OUT OF FUEL, HE CAN'T SEE WHERE TO LAND.

A SHAFT OF
A SUDDEN
BREAK IN T
SHOW THE
SPIRE, THE
LANDMARK
ENGLAND!

T AND

OUDS
EDRAL
ST

THE SAVED PILOT HAS TRAVELLED FROM AMERICA EVERY YEAR SINCE IN GRATITUDE, TO COMMEMORATE HIS GOOD FORTUNE.

AS TOLD TO THE ARTISTS BY HUGH DICKINSON

DIRT

THE ESSENCE OF CELEBRITY

Simon Grennan & Christopher Sperandio

FANTAGRAPHICS BOOKS

Also
Featuring
These Stories
of Celebrity
Dirt

"Are You
Being Served?"

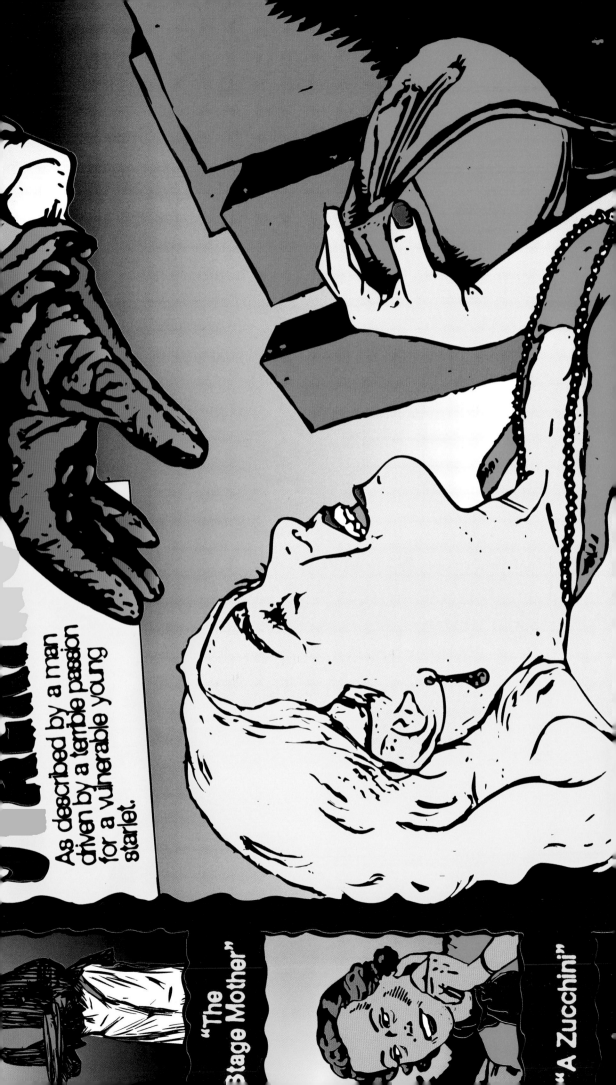

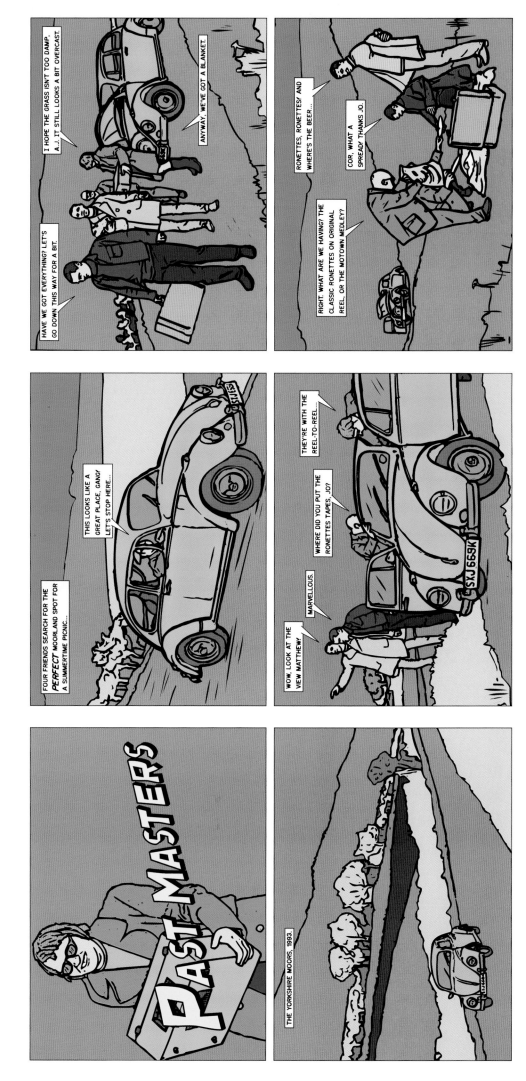

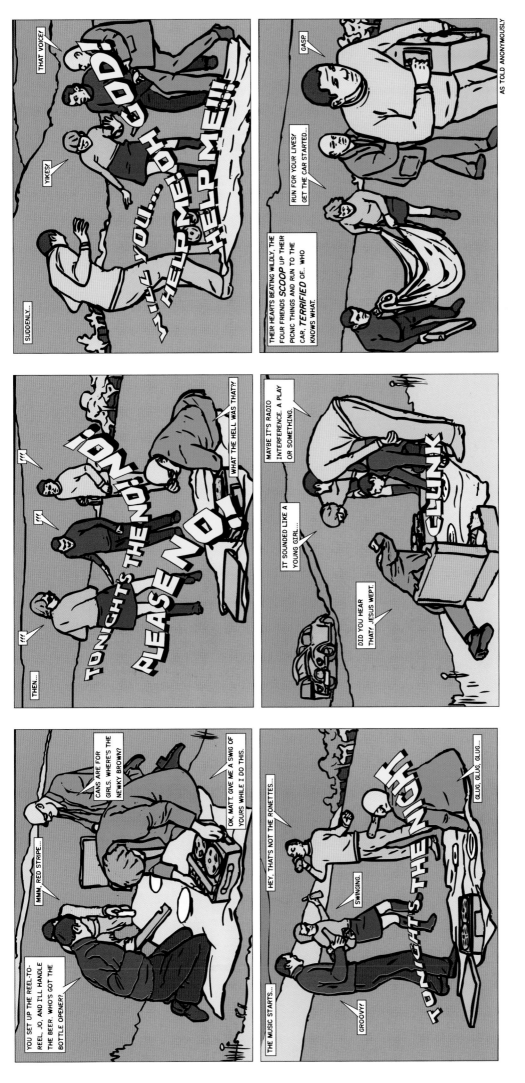

AS TOLD ANONYMOUSLY

27

B-032464

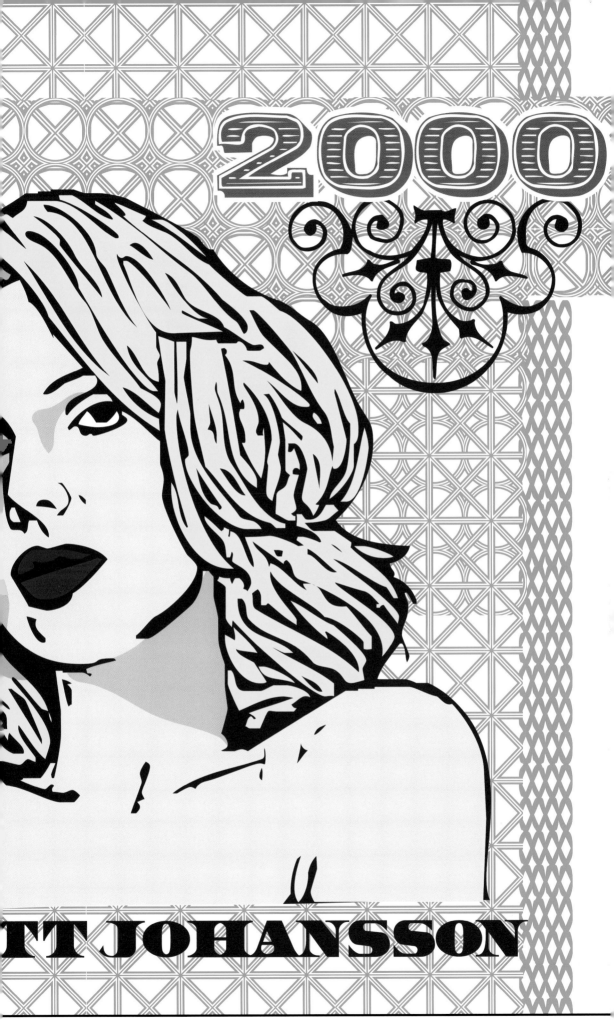

2000

TT JOHANSSON

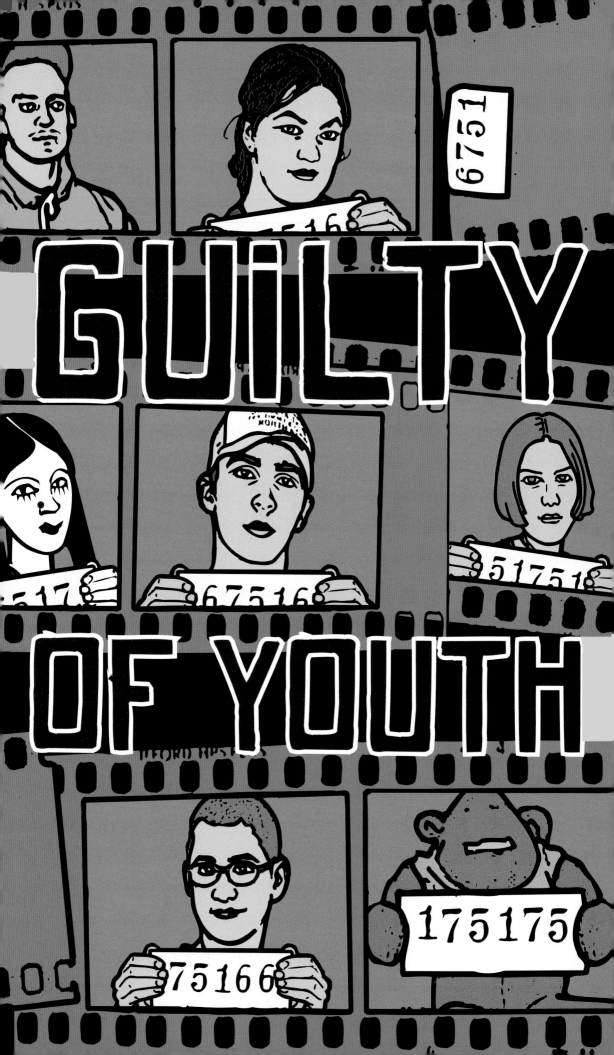

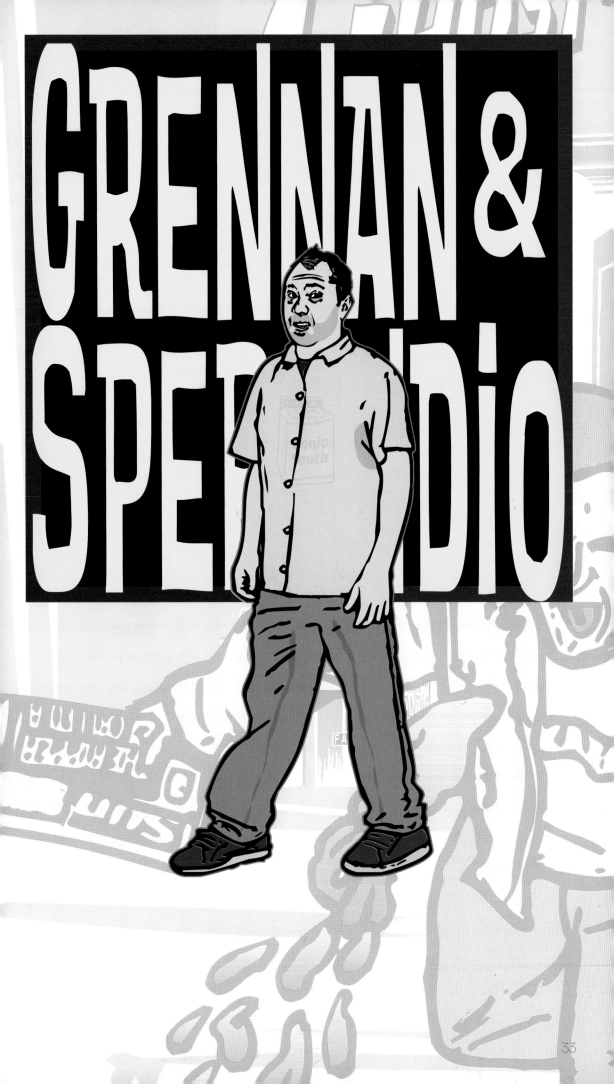

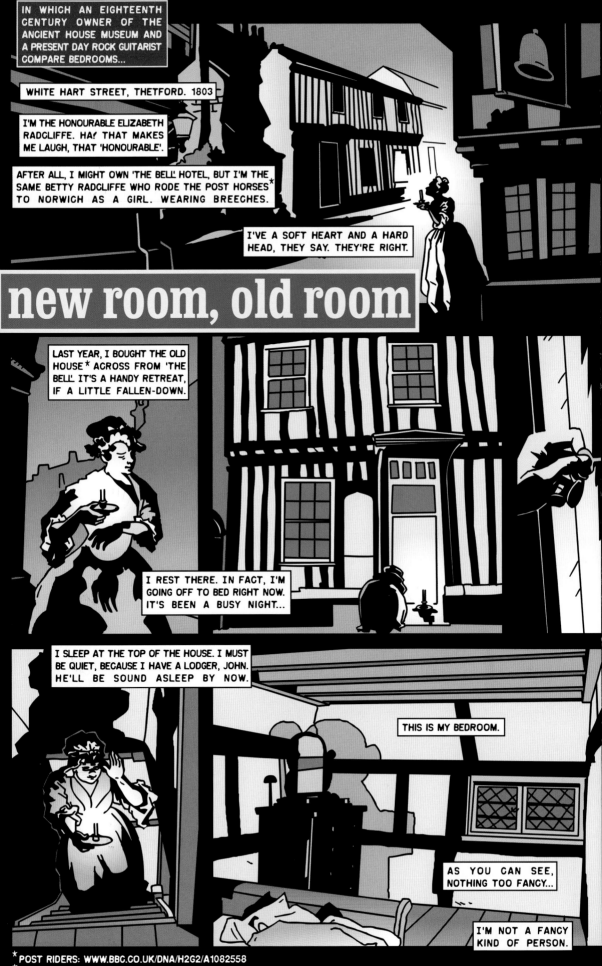

new room, old room

HOT VAPOUR BOAT

EXPANDING WATER **VAPOUR** MAKES THIS BOAT **GO!**

YOU'LL NEED:
EMPTY WASHING UP LIQUID BOTTLE
"TEA LIGHT" CANDLE
30CM LENGTH OF 0.5CM COPPER TUBE
SMALL PIECE OF BLU-TACK
SCISSORS
BOX OF MATCHES

1. CUT THE WASHING UP LIQUID BOTTLE IN HALF AS SHOWN.

2. BEND THE COPPER TUBE INTO A LOOP IN THE MIDDLE, SO THAT EACH END IS THE SAME LENGTH.

3. MAKE TWO SMALL HOLES IN THE BASE OF THE HALF WASHING UP LIQUID BOTTLE AND PUSH THE ENDS OF THE COPPER TUBE THROUGH THEM AS SHOWN (A) AND (B).

4. BLU-TACK THE CANDLE INTO THE BOTTOM OF YOUR BOAT SO THAT THE CANDLE WICK IS UNDERNEATH THE LOOP IN THE COPPER TUBING.

5. HOLDING EVERYTHING IN PLACE, DIP ONE END OF THE COPPER TUBE IN WATER AND SUCK ON THE OTHER, TO FILL THE TUBE WITH WATER.

6. GENTLY SIT YOUR BOAT IN A BATH OR POND OF WATER. MAKE SURE THE ENDS OF THE COPPER TUBES ARE UNDER THE WATERLINE.

WHAT HAPPENS? THE WATER IN THE LOOP BOILS. THE VAPOUR EXPANDS AND PUSHES THE BOAT.

7. LIGHT THE CANDLE AND WATCH YOUR BOAT MOVE FORWARD. OK?

UNDER 16? GET AN ADULT TO HELP MAKE AND SAIL YOUR BOAT.

(A)

(B)

35

Master Plans circa: 2019 A

$	%	&	*	()	_
/	0	1	2	3	4	5
:	;	<	=	>	?	`
D	E	F	G	H	I	J
O	P	Q	R	S	T	U
Z	[\]	^	‹	›
d	e	f	g	h	i	j
o	p	q	r	s	t	u
z	0	1	2	3	4	5
{	:	;	}	~	i	#
a	o	≠	'	'	™	©

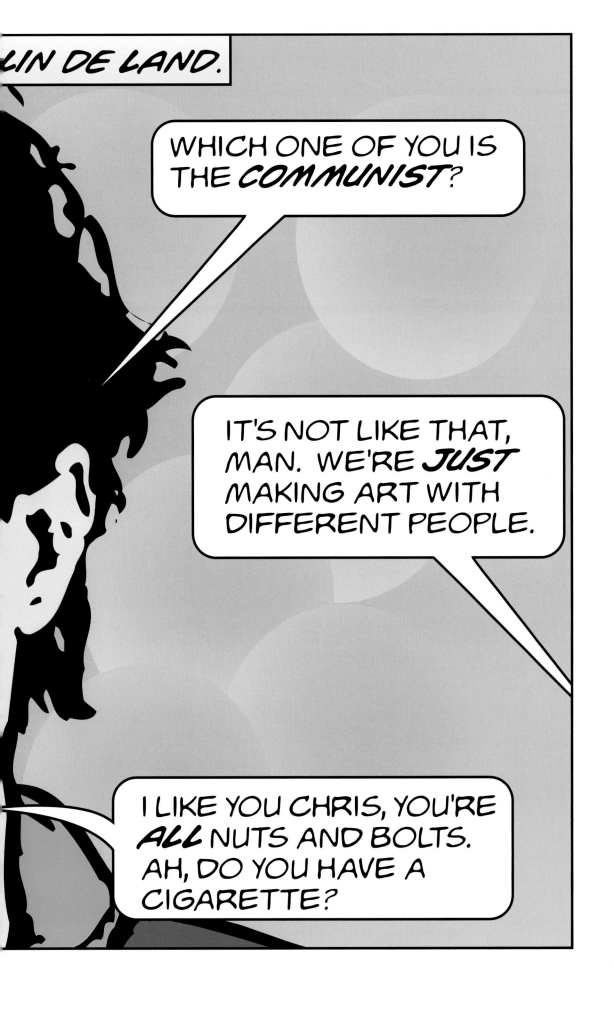

MADE A BRE

Seen the li

searching a b

hear your s

Confidence to

Box 6, 14 St M

Manchester N

FANTAGRAPHICS BOOKS

$3.95 USA $5.50 CAN

CHUMS BE
STARTL

REV

IKON GALLERY

Commissioned by the

AKTHROUGH?

ht? We're re-
ok and want to
ory. Write in
— Revelations,
ary's Hall Road,
6DZ

AY SECRETS IN A
'G DISPLAY OF

GRENNAN &
SPERANDIO

ENGE

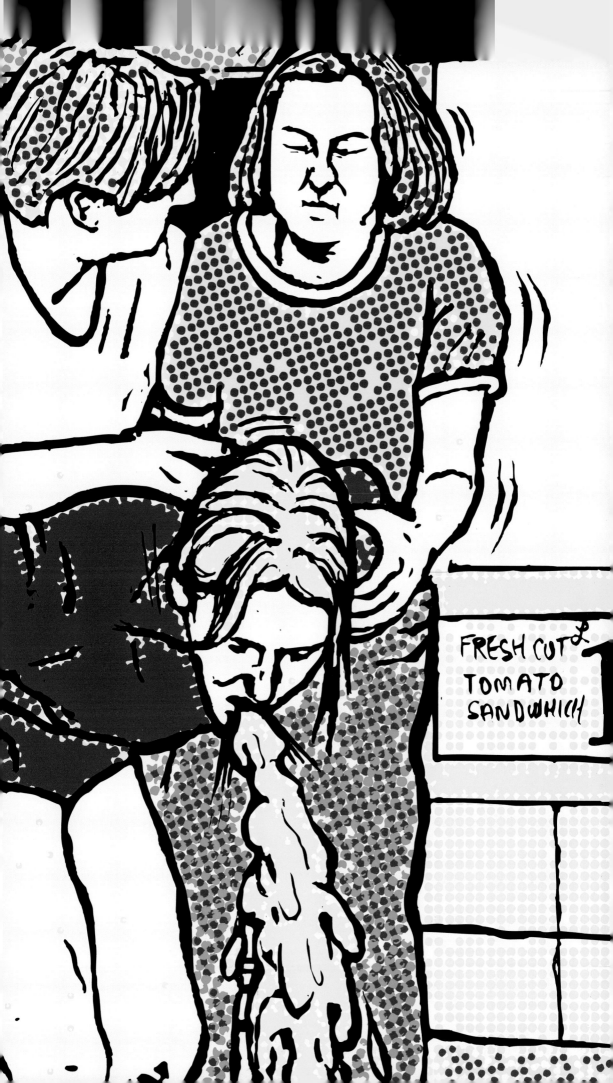

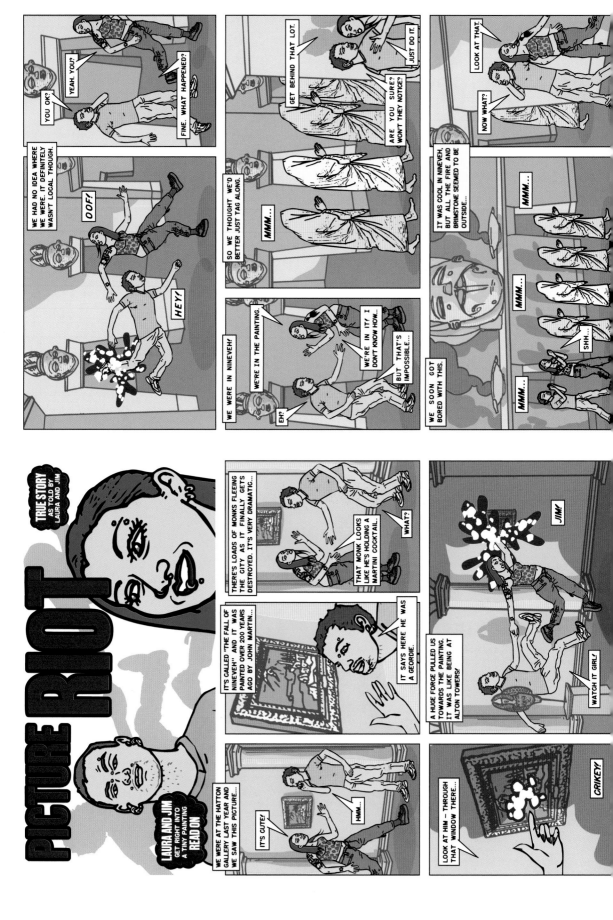

OTHER TITLES BY
GRENNAN & SPERANDIO
FROM FANTAGRAPHICS BOOKS

DIRT
THE ESSENCE OF CELEBRITY

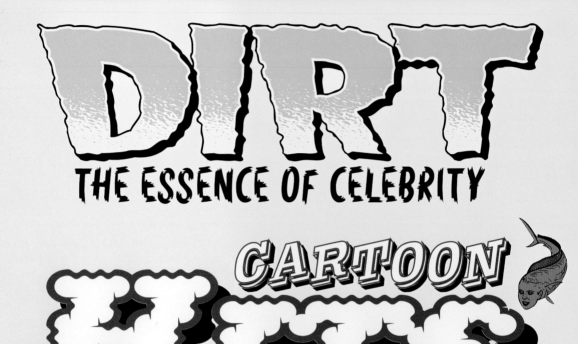

CARTOON HITS

Life in Prison

AND COMING SOON

CRIME STORY

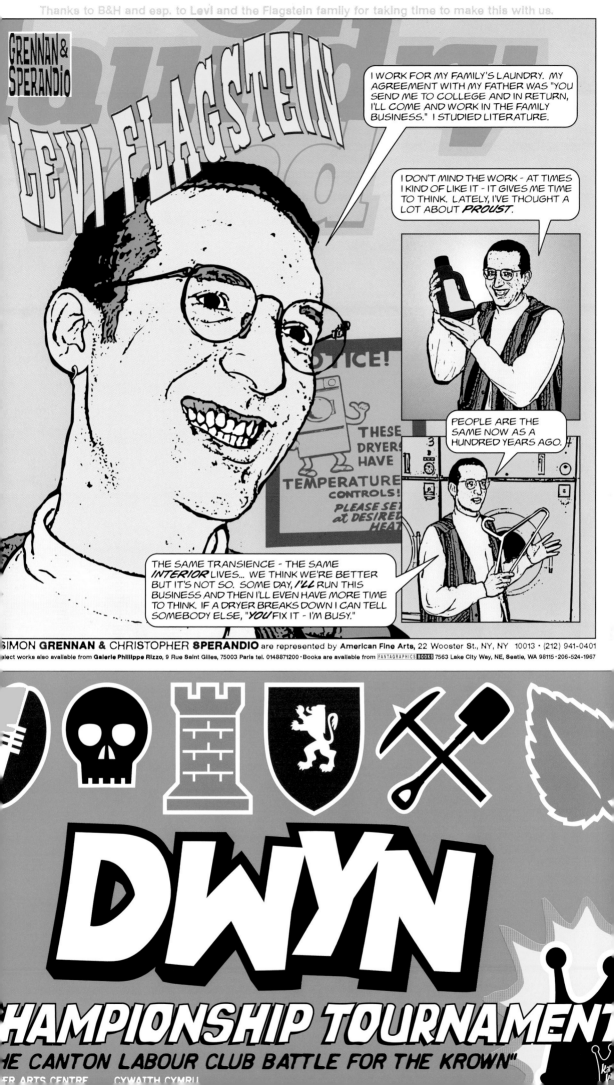

SOHO PARM DELI

307 West Broadway near Canal

MY NAME IS *LUIS CHIRINOS.* I'VE LIVED IN *BROOKLYN* ALL MY LIFE. I LOVE NEW YORK BUT IT'S *NOT AN EASY* PLACE TO LIVE.

I TELL *ANYONE* THAT'S COMING HERE IT'S NOT AN EASY PLACE! BUT NO MATTER HOW HARD IT IS, LIFE IN NEW YORK IS COMING *FORWARD.*

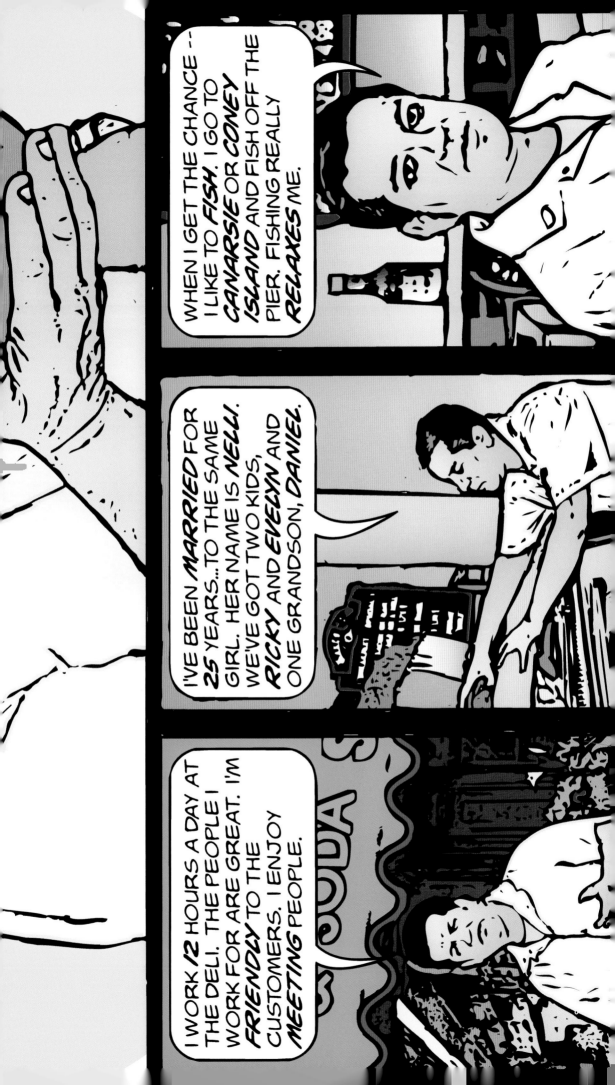

GET DRUNK
AT WORK.

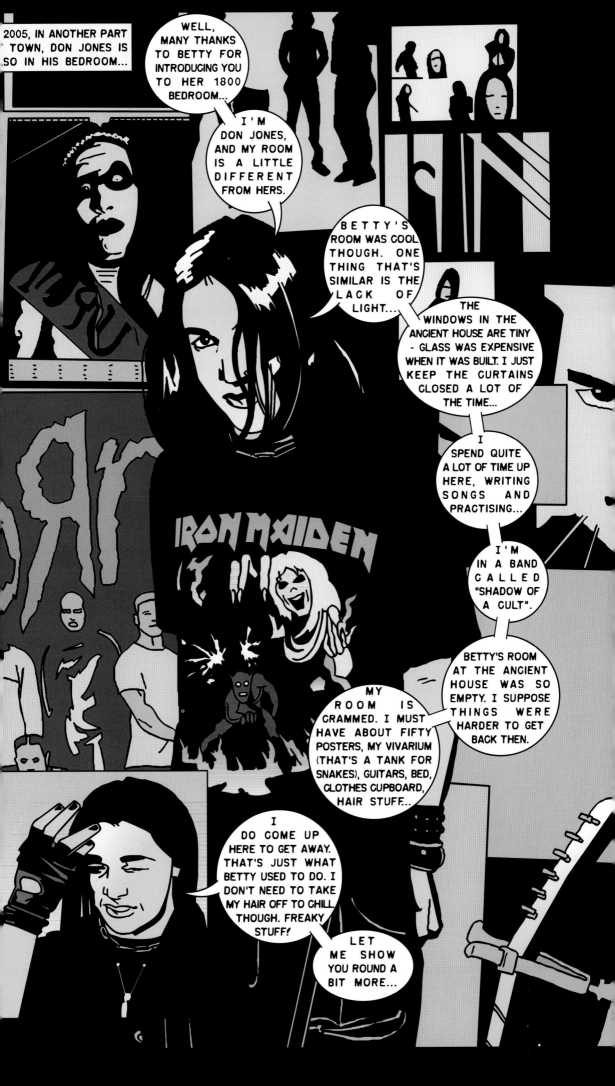

LOOK

THE DAY SEAN KEATING WALKED OUT
OF PRISON, HE SWORE HE WOULD WALK
AWAY FROM ORGANIZED CRIME.

THERE'S JUST ONE PROBLEM...
HIS FATHER WON'T LET HIM GO.

WITHOUT ART I'M NOTHING

on Grennan & Christopher Sperandio

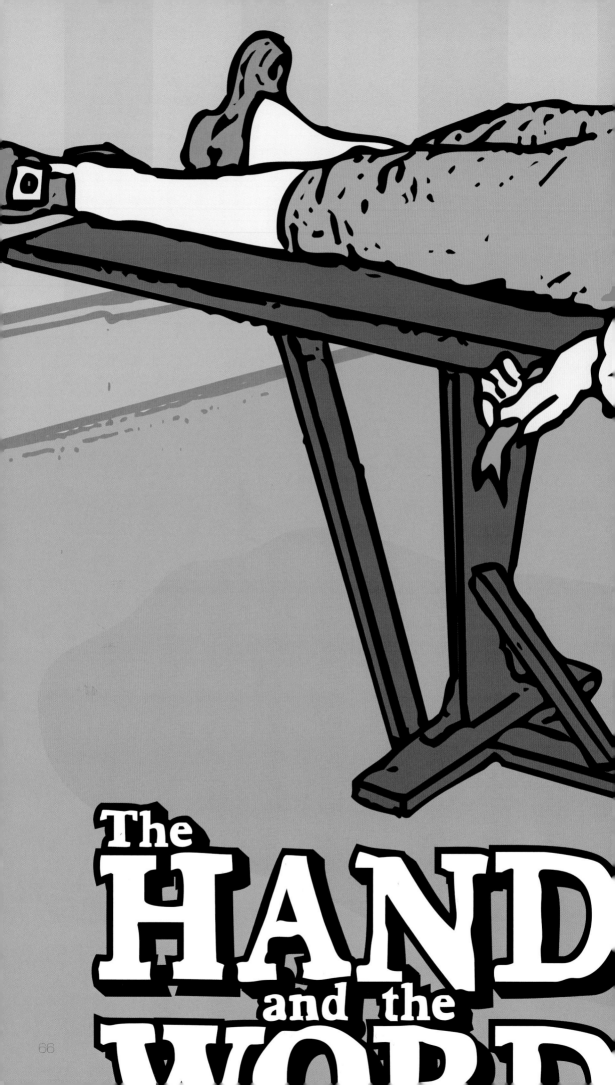

The
HAND
and the
WORD

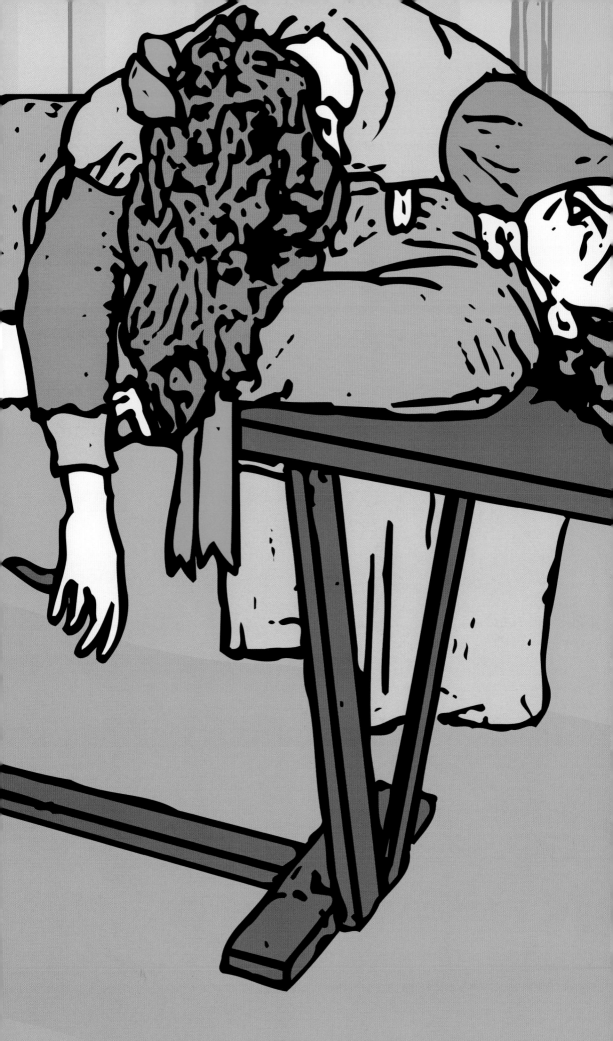

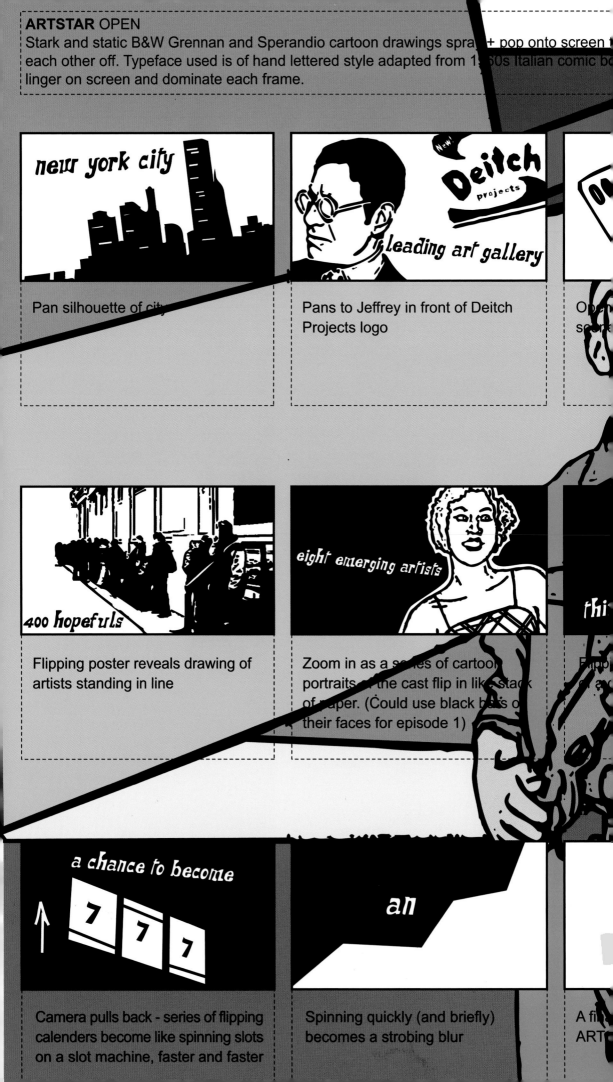

new york city

Pan silhouette of city [...]

Deitch projects · **leading art gallery**

Pans to Jeffrey in front of Deitch Projects logo

Op[...] sc[...]

400 hopefuls

Flipping poster reveals drawing of artists standing in line

eight emerging artists

Zoom in as a s[...]es of cartoo[...] portraits [...] the cast flip in like stack of [...]per. (Could use black b[...]s o[...] their faces for episode 1)

thi[...]

F[...]

a chance to become

7 7 7

Camera pulls back - series of flipping calenders become like spinning slots on a slot machine, faster and faster

an

Spinning quickly (and briefly) becomes a strobing blur

A fi[...] ART[...]

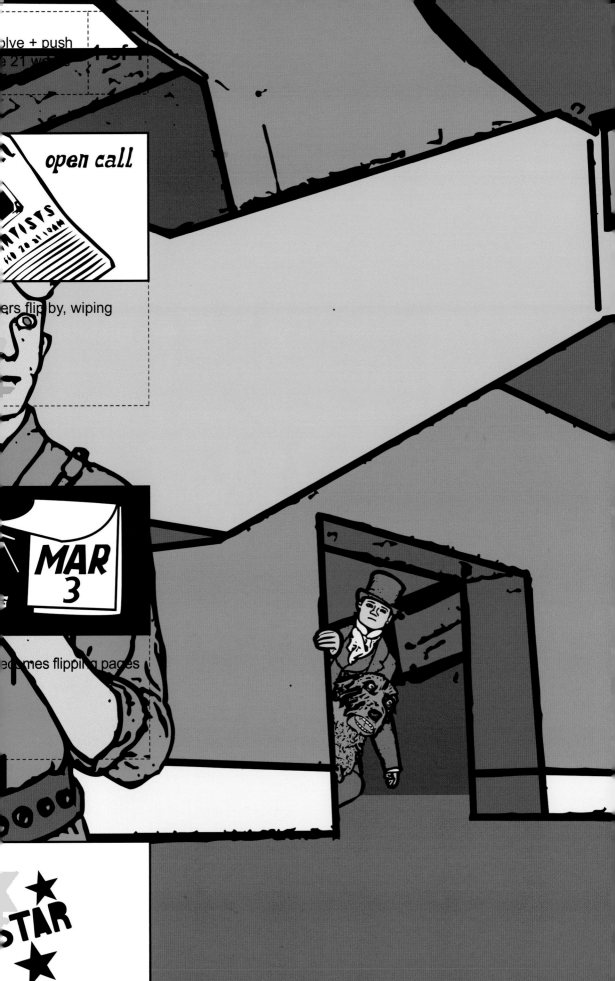

open call

ers flip by, wiping

MAR
3

ecomes flipping pages

STAR

white and the
is all that remains

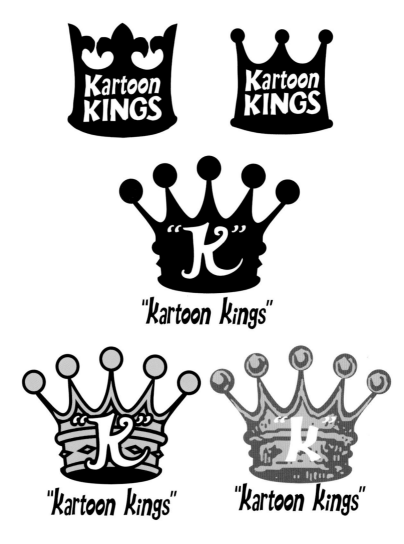

"kartoon kings"

"kartoon kings" "kartoon kings"

Young city centre life revealed in new art film...

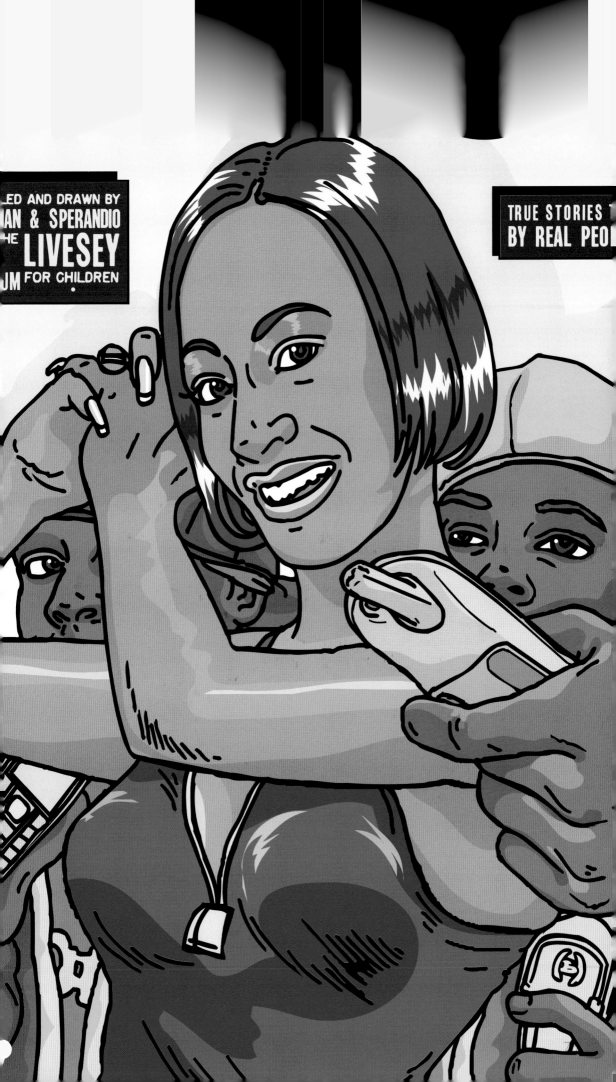

ED AND DRAWN BY
AN & SPERANDIO
HE LIVESEY
UM FOR CHILDREN

TRUE STORIES
BY REAL PEOP

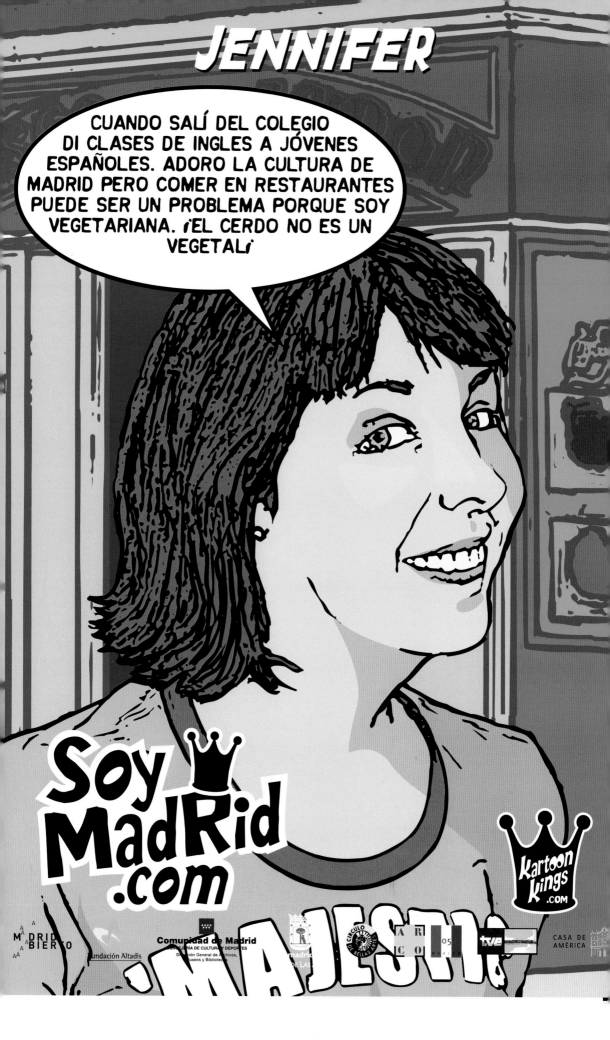

WYN

gardiau NEWYDD i Gymru

i chwarae DWYN yng Nghanolfan
lydau Chapter. Dysgwch y rheolau
ewch chi becyn o gardiau **AM**

sgwch sut i chwarae'r gźm a
owch ar gyfer **Pencampwriaeth**
gyntaf y byd – am 7YH ar ddydd
Gorffennaf yng Nghlwb Llafur
na, Heol Llandaf, Caerdydd

e fydd enillydd y
encampwriaeth yn
erbyn <u>SONY PSP!</u>

n ddysgu sut i chwarae'r gźm a
ecyn o gardiau AM DDIM tra bydd
iwad yn para. Dewch i Ganolfan
ie Chapter rhwng 1YP a 6YH bob
un, Mawrth a Iau yn ystod mis
naf i ddysgu mwy am y gźm
newydd yma, neu gallwch
: **Info@kartoonkings.com**!

ch i safle we DWYN:
artoonkings.com/dwyn

olfan Gelfyddydau Chapter wedi'i lleoli yn
a, tu ôl i Heol Ddwyreiniol y Bontfaen, rhwng
daf a Heol y Farchnad -- o fewn cyrraedd
anol y ddinas. Mae yna faes parcio cyfleus
n y safle ac mae bysiau 17, 18 + 31 yn pasio
Ganolog bob rhyw 5 munud. Ffoniwch 029
0 am fwy o fanylion.

Grennan & Sperandio: Demotic Art and the (Entertainment) Values of Social Agency/Inclusiveness

by Joshua Decter

Grennan: Our art practice was most influenced by . . . the writings of French sociologist Pierre Bourdieu.

Sperandio: Well, that and boredom.

—Simon Grennan and Christopher Sperandio, *Cartoon Hits*

A happy marriage of strategic intellectualism and coy anti-intellectualism might begin to characterize the unusual creative chemistry of Simon Grennan and Christopher Sperandio, a.k.a. the Kartoon Kings. The witty (and deadpan) epigraph above is excerpted from Grennan & Sperandio's *Cartoon Hits*, a 1996 project sponsored by the Institute of Contemporary Art (ICA) in London and distributed by Fantagraphics Books. The artists' banter, which has been included self-reflexively into a number of their publications, perfectly embodies their special working relationship and reflects their paradoxical art practice: an unprecedented fusion of social responsibility and entertainment values that has enabled them to engage a very broad constituency (from cultural specialists to hip teenagers browsing in a comic-book store) and to challenge the art world's orthodoxies of what constitutes "political" art. Grennan & Sperandio inject comic books into the social bloodstream, where these publications can detonate new meanings to diverse readers/viewers.

Grennan & Sperandio have developed a nuanced methodology of collaborative work (in tandem with a catchy visual language inflected by the codes of cartoons) that allows them to smoothly operate across cultural and social divisions as facilitators of other people's imaginations. At the same time, they submit their own artistic methods to scrutiny in ways that are both amusing and ethically responsible. And while the two occasionally lampoon the self-important power playing of the art world, with their trademark Anglo-American sense of humor, Grennan & Sperandio are honest enough to implicate themselves in this web of cultural contradictions. Not only do they keep everyone else on their toes, but they also make certain not to take themselves too seriously, so that they remain, in actuality, accessible to a wide audience. Grennan & Sperandio serve up a spicy version of the quotidian. They want to do some degree of damage to the idea that the only way to connect with the masses is to make (German) spectacles of

themselves (as so many artists seem to do these days), to paraphrase from Mel Brooks's film *Blazing Saddles*.

In the past, various artists have imagined that it was necessary, for aesthetic or political reasons, to reach beyond the relatively insular precincts of the art world and its relatively hermetic codes of vanguardism, and to engage with people "out there" in the real world through strategies of social engagement, participation, interaction, and provocation. In distinct and often contradictory ways, this impulse can be identified throughout a range of historical precedents, whether in terms of models of Realism in the nineteenth century, Dada and Futurism, the revolutionary initiatives of the Russian avant-garde and the Bauhaus at the beginning of the twentieth century, Fluxus and Happenings in the mid-twentieth century, the Independent Group and British proto-Pop generally, the art-life preoccupations of Rauschenberg, the consumer/celebrity fetishism of Warhol, the conceptually driven social-architectural performance/video experiments of Dan Graham, Hans Haacke's Museum of Modern Art (MoMA) poll of the 1970s, or the collectively oriented model of political engagement practiced by Group Material during the 1980s.

The distinction between what constitutes reality and what constitutes art is merely illusory, yet it is an illusion of philosophical and material *difference* that can be reinvented again and again to such an extent that the illusion itself (i.e., the gap between reality and art) seems to disappear and be replaced by other powerful illusions. Today, we live according to the rather persuasive illusion that the status, value, and meaning of contemporary artistic practices have become so unstable that only the most generalizing of social-anthropological distinctions can be offered for our consideration. However, most of us would admit that there is something undeniably "liberating" in the premise that art making is as mundane as any other cultural activity, even though it issues forth new meanings and forms through a specialized language. There really is no paradox: banality and specialization are equal partners in the art game. Art may have the ability to convert the everyday into the extraordinary, or the extraordinary into the everyday, and it may even be able to transform consciousness, but its palpable role in the transformation of social situations continues to remain vexingly undetermined. What truly matters is the actuality of those gestures that point in the direction of an event that occurs at the border of distinct social or cultural experiences, language-codes, expectations, desires, and projections. These borders are elastic in both conceptual definition and material presence. The *event*, so to speak, is the specific articulation that attempts to translate what happens at the border into something conceptual yet material. Art is perhaps the most chameleon of cultural activities, at least on symbolic terms. Art feels quite comfortable wearing borrowed clothing in order to assume just about any sort of identity, and it occasionally travels with a passport bearing a false name, allowing vicarious entry into the *artifice* of the ordinary.

When art seeks to penetrate so deeply into the language of reality that it disappears and then reappears as the aesthetic mirror of that reality, we generally refer to the conceptual/philosophical revolution that Duchamp triggered early in the twentieth century. Within the

various genres that constitute the realm of post-object and post-studio art today, there has been a general tendency to suggest that a penetration of reality somehow guarantees purchase upon an enhanced authenticity, an experience of realness that is understood to be not only symbolically but also materially closer in spirit to everyday reality, whatever that may be. If certain strategies of institutional critique led to a fetishizing of the museum and its attendant structure and ideologies at the start of the 1990s, such practices eventually exhausted themselves by continuously returning to the same host body (i.e., the cultural institution, the art system) for parasitical feeding. It is this tautology, this paroxysm, that Grennan & Sperandio's practice effectively navigates around.

They don't create so-called Public Art in any traditional or even non-traditional sense; they don't plop down large-scale bronze objects in front of corporate headquarters, nor do they build putatively interactive amusement park rides. Rather, the public (lowercase p) becomes a direct collaborator in the production of art, with the artists as facilitators, interlocutors, and, perhaps most significantly for Grennan & Sperandio in terms of their comic-book productions, editors and artistic directors. If anything, they are somewhat connected to the emergence of Project Art (with its historical lineage in Conceptualism and Site-Specificity), as well as "Service/Research" and "Relational" models (loosely affiliated with institutional critique), wherein practices are constituted by degrees of social contingency, interface, and intermediation. Yet Grennan & Sperandio remain in a category all their own because it is a category they have largely invented. Should we call it art in the service of the public? Well, yes, though perhaps the guys might lampoon the self-seriousness of that claim, even as they appear to believe that these collaborative projects do, on some level, have a transformative effect upon people's lives. At the very least, the projects demonstrate that art making can facilitate cultural self-representations that channel the interests and imaginations of people outside institutionalized art circuits.

For Grennan & Sperandio (who are artists but also just regular people, after all), there appears to be a good-natured suspicion of the traditional model of art as an instrument of cultural enlightenment. They don't necessarily buy the idea that if you simply hang a picture on the wall of a gallery or a museum, cultural edification will occur in some type of trickle-down manner and folks will simply become ennobled and enlightened (as if by some stroke of magical cultural osmosis) through encountering art in the white cube. Their approach is based on a fundamental appreciation of, and curiosity about, the lives of people, regardless of their economic, cultural, political, or social station in life.

Grennan & Sperandio's utilization of the comic-book form is perhaps a way to underscore the intrinsic folklore component of populist aesthetics. For them, the language of comics seems to be a means of initiating communication and collaboration with people who are not necessarily familiar with the specialized discourse of contemporary art, and an instrument to recount life-stories through a condensed narrative structure. This is, in spirit and practice, somewhat closer to the codes of mainstream cartoon-based television than to vanguard art—or, maybe, some new blend of the two. Developing new channels of distribution

for art production, Grennan & Sperandio quickly gained the support of a major publisher of "alternative" comic books (Fantagraphics Books) so that projects commissioned by traditional cultural institutions could find a non-traditional avenue of dissemination. Later, for their *Modern Masters* project with MoMA and PS1, they cultivated a relationship with mainstream DC Comics, who published *Modern Masters* in comic-book form.

Is it possible today to imagine a kind of cultural labor that is in between the conditions of art making and entertainment, social consciousness and irreverent humor? Something that is at once politically engaged yet splendidly skeptical? Something conceptually complex yet utterly accessible? Grennan & Sperandio's art practice, which might also be referred to as *cultural labor for the fun of it*, poignantly embodies—and moves productively beyond—the aforementioned contradictions. They have never been entirely comfortable with the idea of art as an autonomous activity disengaged from the routine, occasionally banal, aspects of existence that all of us muddle through. They have chosen to ignore the idea that the public is just some amorphous mass to be manipulated for passive cultural reception, instead inviting those individuals who are usually relegated to the role of passive audience members to transform themselves into co-authors with the artists. The artists rearticulate and reanimate the narratives of others through editing, yet at the end of the day it is these other voices that remain the focal point. In other words, authorship becomes a kind of collaborative venture in which the product or—in the case of art practice—the object can no longer be considered, on either conceptual or practical terms, a completely autonomous thing. In fact, that the "object" of art, beyond becoming dematerialized or dispersed as a physical thing (or ideational entity), takes on the form of (or is transferred into) another kind of cultural product: namely, in the case of Grennan & Sperandio's practice, the comic book, the animation, and even the television show are the vehicles through which the stories of people are re-narrated into an entertaining form of social realism designed for cultures of visual consumption.

For Grennan & Sperandio, authorship has always been a collaborative venture, on all levels of the production process. This is true not only in regard to the actual process of their transatlantic artistic collaboration since 1990 (Grennan is based in the UK, and Sperandio in the US), but also, and perhaps more significantly, in terms of how their partnership is emblematic of a broader social partnership they have successfully built into the methodology of their practice. Specifically, not only have they made a continuing process of developing projects that are responsive to particular communities in a range of urban, rural, institutional, and other contexts, but they have also made their projects fundamentally contingent upon the participation of individuals in order for the work to come to fruition.

This cleverly provisional team-based method puts a new, good-humored, and mildly ironic spin on a tactic that, until recently, has been largely in disrepute: a collective, socially based model of art making that seeks to throw a monkey wrench into our well-trodden belief system of stable authorship and to intelligently mock the cultural authority

that such deep-seated beliefs inevitably, and predictably, reinforce. Grennan & Sperandio peel back the framework even further so that outsiders are brought into the conceiving stage of the art process. Their methodology is contingent upon a sort of radically extended collaborative process whereby authorship is fundamentally displaced into—and, to a certain degree, replaced by—a set of distinct voices. Playing in that symbolic and all-too-real chasm separating the putative art culture from the putative non-art culture, the two collaborators renegotiate the often estranged relationship between artist and audience, modestly transform the public into producers, and suggest that a Pop sensibility can also engender unique social transactions and hybrid aesthetic forms.

In their collaborations with a system of international cultural institutions (a method of working that facilitates the ongoing commissioning of new projects), Grennan & Sperandio engage individuals to share their stories about particular life experiences, and they select—through an editorial process—those elements that are the most representative of the author's voice. At once conceptually sophisticated and defiantly accessible, their method of obtaining real-life stories from members of diverse communities and then re-presenting these raw materials in condensed pictorial and textual narratives for comic-book publications suggests that Grennan & Sperandio are fundamentally interested in functioning as social *transcribers*. They have always started from the premise that the artist plays the role of an intermediary, facilitator, and interlocutor for and with others in cultural and social spaces, and that the authentic voice of the artist actually need not be anything more than a tool used for the artful amplification of other people's experiences, desires, fantasies, dreams, and voices.

Rirkrit Tiravanija, an artist who emerged on the scene at the same time as Grennan & Sperandio in the early 1990s, has endeavored to "open up" the self-contained artwork to an imminent social intervention, setting up a framework that prepares the ground for the unfolding of some kind of event. The social activity "completes" the signifying conditions of the art practices, at least within the context of art galleries and museums. This, then, sets into motion a unique kind of theatricality that resembles real life (certain life-rituals, or the systems of mass culture) but actually points back to the real artificiality of the framing device itself. In this conception, the museum is brought into the realm of the mundane, and in return, certain everyday activities are converted into their aesthetic corollaries. Tiravanija will construct an environment in which a specific kind of social activity can unfold, but this will also be understood as a rehearsal for corollary activities or social transmissions that occur outside of the frame of the cultural institution (the museum or gallery). Tiravanija's practice does not imply that the museum is in any fundamental sense less real than any other cultural context: to the contrary, he sets into motion a folding together of social spaces, and meaning emerges out of that symbolic and material bending of one structure into another.

By occasionally inserting themselves (as the characters Grennan & Sperandio!) into their own comic narratives, they add a layer of self-referentiality that is as shrewdly critical as it is amusing. This is a

significant accomplishment, particularly given how seriously the art world tends to regard itself and how, traditionally, artists who engage with social and political conditions don't often have much of a sense of humor about their practices. Of course, Grennan & Sperandio's work is as serious as you can get, precisely because it offers an indication of how people desire to articulate representations about their own lives, facilitating a process through which people determine the way their portraits, in a sense, will be iterated by the artists' lively and imaginative pictorial styling.

The evolution of their practice is instructive, revealing a consistently ethical relationship to the public. Grennan & Sperandio, perhaps unlike any artists before or since, have been able to cultivate the trust of diverse communities. Without this trust, which is reciprocal, their projects could never have happened. In 1993, within the context of Mary Jane Jacob's "Culture in Action: New Public Art in Chicago," Grennan & Sperandio developed a project that would quickly put them on the map of the international art-world. After conducting field research for the context-specific framework of "Culture in Action," they began a process of teaming up with workers at a Nestlé chocolate plant in Chicago (specifically, members of the local Bakery, Confectionery, and Tobacco Workers' Union) to assist them in the making of a brand-new milk-chocolate-and-almonds candy bar. The project, entitled *We Got It*, involved a close collaboration between Grennan & Sperandio and the unionized workers as they produced, packaged, and even designed advertisements for the new candy bar. As the project developed, Nestlé sought to quash it by reneging on their commitment to provide support: the workers responded to their employer's reversal by threatening a strike, and the project was finally completed.

The *We Got It* candy bar became the artifact of this complex process, the evidence of an unprecedented collaborative art project that empowered the imaginations of workers in a respectful, thoughtful, and playful manner. Grennan & Sperandio cleverly responded to Karl Marx's primary complaint about the alienation of the worker from his or her "object" of labor in the age of industrialization by offering these chocolate makers an opportunity to participate in the creation of all aspects of the product—and partake in, if not the profits, the symbolic fruits of their adventurous cultural labor. Thousands of the fifty-cent candy bars were distributed throughout the Chicago area, and some were presented at the Andrea Rosen Gallery in New York (within a specially designed point-of-sale display container), illuminating how the function and meaning of this candy bar (collaborative artwork versus consumer good) subtly shifted depending upon its context of presentation.

And it was in the same year, 1993, that Grennan & Sperandio's work initially came to my attention by way of their ingenious project *Anyone in New York*. Commissioned by New York University's Grey Art Gallery, Grennan & Sperandio contacted a range of people employed by the university and engaged them in discussions about whom they would most like to meet in New York City. And then they went about fulfilling those desires. This remarkable process yielded a series of photographs, providing the documentary evidence, if you will, of those successful

meetings that were consummated. Plugging into the contradictory reality of New York as a mythological place of endless opportunity yet mediated access to those opportunities, Grennan & Sperandio offered their services as cultural interlocutors who could make these fantasies come true by establishing the right network of social connections and permissions (or by just transgressing real/imaginary hierarchies of power). *Anyone in New York* gained notoriety in—and was taken seriously by—both the mainstream and the art presses, a considerable achievement in its own right. It was a project that redefined the terms of how artists might not only imagine themselves in relation to people out there in the real world but might actually create a working relationship with people from various cultural and educational backgrounds, in part by gaining their trust. Grennan & Sperandio were well on their way to forming a thoroughly imaginative art practice that was at once conceptual and populist—and socially generous in a fundamental way.

In 1994, the artists asked six dentists living in Eastbourne, England, to select their favorite paintings. They then photographed each dentist (with their respective office assistants) in the compositional guise of their chosen painting, a funny gesture that was somehow appropriate in how it suggested poignant (if a bit absurd) linkages between art history, art language, personal taste, and the here and now of day-to-day life. And so the photographic works entitled *Six Eastbourne Dentists* functioned as a kind of hilariously revisionist type of art education, a rather ingenious attempt by Grennan & Sperandio to reveal how silly acts of (enforced) mimicry (that could have almost been inspired by a Monty Python skit) can actually reveal much about people's relationship to pictorial language and representation.

Grennan & Sperandio's first full-fledged comic-book project was developed in response to a 1995 site-specific group exhibition within the context of an old, disused prison in Philadelphia. Here, the collaborators solicited and obtained a number of real-life stories of incarceration and created the book *Life in Prison*, which was published by Fantagraphics. Their affiliation with Fantagraphics meant that their projects would now be distributed nationwide in many comic-book stores, providing access to an audience broader than that of galleries and museums alone. In *Life in Prison*, the first story is actually a true-to-life recounting of how Grennan & Sperandio developed their work for the site-specific project. We observe Sperandio chatting with the show's curators about various aspects of the site, revealing the collaborative process between the artists. Here is a sample of the dialogue:

> Sperandio [on the phone with Grennan]: Hey! I'm just back from Philly. They'd like to commission a new artwork. This would be a good time to do that comic book idea we had.
>
> Grennan: We could make a comic book about prison life, but there's just one problem. Neither of us has done time.
>
> Sperandio: Well, my brother did 30 days in the county jail. We could talk to him . . .

The final image in this introductory story shows Sperandio rising up from a toilet seat, the phone in one hand, and his other hand pulling up his trousers. And, of course, they do include Mark Sperandio's jail story in the comic book, making it a complete family art affair. As this is the pair's first comic-book project, it is important to note that at the back of the publication they picture themselves in action-hero poses (or, super-artist poses), once again engaging in lively self-deprecating humor. But it is also on this page that Grennan & Sperandio posit their basic working methodology in a refreshingly transparent and humorous manner. In terms of the visual language of this inaugural comic book, these particular self-referential texts are designed to appear as e-mail messages—another allusion to their communication process as transatlantic collaborators:

> S & C: Since 1990, artists Simon Grennan & Christopher Sperandio have co-created new artworks that act as bridges between diverse communities. They are progenitors of a model of the artist as socially engaged facilitator.
>
> Simon: Simon thrives on a diet of teas and dry toast. He lives in Manchester, England.
>
> Chris: Chris loves coffee and eats all the wrong foods. He lives in New York City.
>
> ESP: When not sitting in airplanes, the pair are linked via modern telecommunications equipment and a singularity of purpose akin to telepathy.

In *Cartoon Hits*, the two worked with thirteen ICA members to re-create their stories in a comic-book publication. The cover features the cartoon-proxies of Grennan & Sperandio in shackles, anchored at the bottom of the ocean, and surrounded by piranhas with the faces of the ICA members. The book is replete with alternatively engaging and mundane tales, but with Grennan & Sperandio's unique ability to reinvent everyday occurrences with the twist of hip typography and complex graphics, the narratives come alive in an entirely new way. At the end of the publication, cameo portraits of each of the respondents (with red targets superimposed over their physiognomies) are featured along with their comments on the ICA. Here are a few samples:

> And now for a few last words about the ICA straight from some of the stars of *Cartoon Hits* . . .
>
> "Subversion, Hype, Hope and some Good Surprises."—Roberto
>
> "The ICA sticks its fingers down the throat of art."—Lloyd
>
> "Great films, food and ambience. I love going to the ICA and hanging out with my friends."—Kate

*Fantastic Sh*t*, produced in 1996 and presented at the Colin de Land Gallery in New York (among other venues), looks at the

phantasmagorical, mythological, mystical, and hallucinatory aspects of life, visualizing the written accounts of a group of people who claimed to have had experiences of a supernatural kind. Grennan & Sperandio placed advertisements in the local newspapers of New York, Glasgow, and Bordeaux (the project was also presented at the Centre for Contemporary Arts in Glasgow and the Musee d'Art Contemporain in Bordeaux), soliciting written testimonies about people's inexplicable experiences. After consulting with as many respondents as possible in order to incorporate their aesthetic recommendations, Grennan & Sperandio then initiated the next stage of their collaborative process and set to work translating the autobiographical narratives into visual analogs: silkscreen-on-paper posters designed to be viewed with 3-D glasses. They gave visual form to the seminal moments in the respondent's written accounts of their encounters with the supernatural. In the piece based on respondent Ann Dickinson's firsthand testimony, a Christ-like figure emerges from a background of red and green patterned wallpaper and appears to drift beyond the confines of the depicted room—a kitschy representation of Dickinson's sublime spiritual encounter. Jose Gonzalez, another respondent, believed that when he posed questions to his wooden bowl, it voiced yes and no responses channeled through outer space, and that the bowl led him to discover a hidden corpse; his account is interpreted as a humorous yet disturbing take on the still-life genre: a pair of eyes (presumably Jose's) stare at a bowl emanating mysterious rays. And, in a nod to their art-making process, Grennan & Sperandio produced a number of comic-book style panels that introduced the project (and themselves) to viewers by offering a glimpse of the business relationship between the artists and their dealer, reflexive gestures that deliver the critique of art-world institutions into the realm of comedy.

In late 1996, Grennan & Sperandio published their second comic-book project, *Dirt*, which was a commission from the Museum of Fine Arts (MFA) in Boston. The museum had asked the duo to solicit true stories from people about their experiences, or preoccupations, with celebrities. I'll allow the director of the MFA in Boston, Malcolm Rogers (depicted at the front of the book with a stitched-up wound on his forehead and holding a copy of *Dirt*) to explain the circumstances of the project:

> "Hello, my name is Malcolm Rogers and I am the Director of the Museum of Fine Arts in Boston. This comic book that you are holding is not a comic book at all—or rather it *is* a comic book but it's also more than a comic book. It is a piece of art created for this museum by artists Simon Grennan & Christopher Sperandio.
>
> For reasons of our own, we've asked young Chris and Simon to make a new artwork about celebrity. They've decided to make a comic book about celebrity from the perspective of four non-celebrities. We hope you enjoy *Dirt* and thanks for stopping by the museum."

By offering a platform to the museum's director at the start of the publication, Grennan & Sperandio make visible the complex and often contradictory aspects of institutional commissioning/collaboration.

Dirt was really the first comic to function, in certain respects, as an indirect critique of the sponsoring institution. To the extent that the book focuses upon the four stories, it also subtly illustrates the intrinsic power dynamics that inform the relationship between patron (or in this case, patronizing museum) and artist. And, on the flipside of the page featuring Rogers's promotional introductory words, we discover a very significant reflection by Grennan—well, Grennan in the guise of a figure depicted within an appropriation of a 1789 drawing not in the collection of the MFA in Boston (*chuckle, chuckle*):

> "This book will exist simultaneously as an artwork hanging in the museum and as a comic book sold nationwide. We find it highly appealing that an artwork aiming to depict relationships between perceived base or common and the elevated or fine, is itself involved in a conflict of forms, propriety and cultural hierarchy."

Actually, I could not have said it any better myself, and indeed Grennan & Sperandio have a special knack for building into their narratives this kind of entertaining yet deeply sophisticated reflection on the conceptual and material operation of their practice.

In 1997, the National Museum of Photography, Film and Television in Bradford, England, commissioned *The Bradford One Hundred*. In collaboration with the museum, Grennan & Sperandio solicited and gathered brief autobiographical statements from one hundred Bradford residents. The artists used these statements, as well as images of the respondents, to create representative "portraits" of each individual. The comic book is a kind of anthropological/sociological cross-section or mosaic of residents of the city, and if one reads it closely, one can discern the changing cultural, political, and economic history of this urban place through the participants' responses. On the cover, Grennan & Sperandio insert the motto "Comics made with Everyday Heroes," signaling the demotic character of this compilation.

1998 was a very busy year for the collaborative team, as they produced at least three distinct projects with institutions in the US and UK. Commissioned by the major British cultural initiative, Art Transpennine 98, *Ghost on the Stair and Other Stories* gathered together "astonishing stories" from individuals living in cities such as Leeds, Manchester, and Liverpool. Grennan & Sperandio placed advertisements in thirty-five newspapers to solicit true stories, resulting in "nine 'true' tales of personal epiphanies in the post-industrial north of England. Each story is one of discovery and transubstantiation—the nine storytellers have all experienced sparks of light in a land blackened by the golden age of the machine."

In "Ghost on the Stair," the eponymous story, Grennan & Sperandio depict the storyteller, William Dent (from the city of Saltaire) sleeping alone in his bed around midnight, when a "thump" and a "scuff" awaken him. Startled, Dent gets out of bed, opens the door, and observes a white-yellowish glowing light hovering in the stairwell. The final frame of the narrative features Dent asking of this mysteriously nebulous entity a rather poignant question: "Son?" The economy and subtlety

of Grennan & Sperandio's depiction create a sense of intrigue and suspense for this ghost story, making it especially striking; it is almost as if the reader is watching a silent movie unfold. In other words, it is a kind of visual pantomime. I would suggest that *Ghost on the Stair and Other Stories* is connected to their 1996 project *Fantastic Sh*t* in terms of genre: in both, what might be considered irrational becomes a kind of new folkloric language of private resistance (yet made public through the comic book) to the hyper-rationalized conditions of a society organized under the auspices of late industrial, capitalist economies.

In August 1998, *The Peasant and the Devil* was published, the result of a project in which the artists had been invited by the Seattle Art Museum to respond to the museum's exhibition "Cindy Sherman: Allegories." As the description on the back cover of the comic book indicates:

> In the *Peasant and the Devil*, a group of friends act out some of the oldest European tales against a contemporary background, inspired by the role-playing of New York photographer Cindy Sherman.

The project engages the relationship between people's imaginations and the language of art as an allegorical structure through which imaginary relationships to reality are symbolically constructed and articulated. Here, Grennan & Sperandio are essentially portraying the way people re-appropriate art (in this case, the loaded iconography of Sherman's historically-minded pictures) for their own purposes as a means of acting out the possible interconnection between history and the present. The artists perform their own act of appropriation in terms of establishing a parasitical connection, albeit consensual, to Sherman's visual language, and by extension, they give permission to reimagine their lives through the power of allegory.

In December 1998, Grennan & Sperandio shifted into new and fertile territory, producing a comic book for the Grossman Gallery at the School of the Museum of Fine Arts in Boston, entitled *Art School Superstars*. This is one of their most hilarious and poignant works, as it presents cartoon portraits of students, featuring (for better and worse) their opinions about art, the school, and their aspirations. The compilation is respectful, yet by giving voice to these relatively naïve young adults, it opens the possibility for certain students to make embarrassingly self-important comments. Here is one of the most extreme examples:

> "My name is Tedd Bobb and I've attended the School of the Museum of Fine Arts, Boston for one year."

> "I'm studying art to rip the system."

> "My favorite artist is me!"

> "I'm not very happy that Larry Flynt discontinued publication of *Rage*."

> "The world is not right because I'm not a mega-star and Hanson is."

In this one portrait, Grennan & Sperandio effectively illuminate the extent to which careerism is always a by-product of the education of the artist. Bobb's declaration is emblematic, unfortunately, of an attitude among certain art students (perhaps emergent in the 1980s, and reaching a fever pitch these days) wherein the desire for fame and fortune precedes the desire for knowledge, or even talent. As neutral mediators, Grennan & Sperandio are just helping to facilitate these self-presentations, perhaps with the hope of providing a mirror for these kids to check their own attitudes and behavioral postures. Thus endeth the lesson!

If you happened to travel through New York City's subway system in May 1999, you might have noticed something rather unusual about the interior of certain train cars: interspersed with the usual array of ads, there was a series of vividly colored comic strips. These cartoons were not some hip, alternative promotional strategy for a new product or service, but instead a unique art project, *The Invisible City*, conceived by Grennan & Sperandio and commissioned by the Public Art Fund. As indicated in the comic book published on the occasion of the project, *The Invisible City* comprised "stories by people who work at night as told to artists Grennan & Sperandio." In order to begin the process of soliciting responses, the artists used the classified section in newspapers, distributed flyers, and canvassed a wide range of companies and businesses. Later, Grennan & Sperandio met with respondents, engaged in further discussions, selected a final group of workers, photographed them in their respective workplaces, and began translating their anecdotes into comic-narratives. All of the participants—well, I'll call them co-producers or co-authors—reviewed Grennan & Sperandio's progress, making comments and revisions along the way, as is usually the case with Grennan & Sperandio's projects.

The resultant mini-narratives are at once humorous, sad, and strangely familiar. There is nothing cloying or uncomfortably humanistic about the tone of these strips; on the contrary, they are deliciously blunt and occasionally inflected by a sense of irony perhaps triggered by each participant's opportunity to reflect critically (or cathartically) upon his or her own situation. For example, we are offered "Naked Fate" (as told by Ali), in which an aspiring comic-book artist recounts a brief period in her life when she worked nights at nude bars in midtown Manhattan. Or, there is "Entertaining America" (as told by Evan), in which a guy seems a bit depressed about functioning as a late-night operations technician at a cable TV network. Although there is a smudge of pride in Evan's telling us that he is responsible for "running the shows and commercials that are airing" on late-night television, he does not seem to be wholly content. Or "Please Flush" (as told by Kathy), the story of a young woman who understands all too well the absurdity of her life-situation: an "educated, talented ambitious woman" whose means of employment is cleaning toilets and offices. And there is also Khalil, who works at the security reception desk of a college and reflects upon the effects of sleep deprivation and short-term memory loss. The majority of the comic books were given away, free of charge, to anyone who ordered the publication on the Public Art Fund's Web site. Grennan

& Sperandio set up a message board at the Web site, on which they received a large number of positive responses from subway riders who had seen the comics and connected with the stories depicted there. *The Invisible City* made visible the enduring power of reality-based social allegories conjugated across the territory of the city. This is a strategy of urban presentation and engagement that Grennan & Sperandio further amplified in their 2005 project *Soy Madrid*, developed for the "Madrid Abierto" exhibition event, which will be discussed shortly in this essay.

In 2001, Grennan & Sperandio presented one of their most ambitious and complex projects, *Modern Masters*. They solicited stories by individuals affiliated with, and outside of, MoMA and PS1, the institutions that commissioned the work (e.g., Rob Storr, former curator at MoMA, who initiated the project for that institution; Alanna Heiss, director of PS1; Glenn Lowery, director of MoMA; Sienna Alia Staunch, an aspiring art student; Ralph Perez, a building service worker at PS1). The comic book also represented an unprecedented coup for Grennan & Sperandio: DC Comics, the largest publisher of comics in the world, co-published the work with MoMA and PS1, facilitating Grennan & Sperandio's major breakthrough into the mainstream.

Modern Masters is, on a certain level, an entirely new kind of institutional *critique* that operates, simultaneously, as institutional *collaboration* while subtly acknowledging the contradictory nature of the situation. It offers us a window into the arcane operations of these cultural institutions, and the curatorial and administrative personalities who populate them, laced with delicate, good-natured parody. Yet there is not complete transparency, of course, because cultural institutions never can reveal themselves completely to us, for fear of undermining their own claims on cultural authority, which Grennan & Sperandio fully understand. The mystique of the arcane is always necessary, and so Grennan & Sperandio had to negotiate with, and navigate around, the institution's desire to exercise editorial control over the content of the stories. Based upon my communication with the artists, it is apparent that there was a struggle for control of content—specifically, what stories could be told, and how they should be told. The comic book features an alternation of narratives from institutional insiders and institutional outsiders. We encounter Rob Storr (in "Curator as DJ") reflecting upon the curatorial activity of installing artworks for an exhibition as akin to a DJ mixing music (based upon his experience with after-hours radio-playing installation crews at the museum). Perhaps Storr is exposing his not-so-sublimated urge to remain culturally hip while working inside the original white-cube art institution. He is depicted by Grennan & Sperandio in front of a cartoon-version of Mondrian's "Broadway Boogie-Woogie," while lyrics from Britney Spears's ". . . Baby One More Time" drift by. Storr says:

> "Sometimes, when the museum is empty, the installation crews are pumped, there are paintings scattered around the floor and there are CDs scattered around as well. Being a curator IS being a disk jockey."

And, in "Modern Art Made Me Sick," an office worker in midtown Manhattan (who preferred to remain anonymous) eats a hotdog from a street vendor on the way to her first ever visit to MoMA. Upon viewing the museum's selection of Cubist paintings, she is overcome with nausea and proceeds quickly to the bathroom to vomit.

As she is spewing, Ms. Anonymous says:

> "I suppose the combination of things—wolfing my food, the exertion and the excitement—took its toll on my poor stomach.
>
> Or maybe the cubist painting made me sick—ha ha!
>
> Seriously, I think it was the hotdog.
>
> I love Cubism. I still come to the museum quite often—and I just started going to PS1—but I don't buy hotdogs from street vendors anymore."

She offers her reflections while standing in front of cartoon renderings of paintings that do not exist in MoMA's collection, such as a Lichtenstein-like hotdog-in-bun still life.

From the depiction of fake Pop art (which is a bit of a tautology) within the context of a cross-cultural comic book / artwork, to the desire to penetrate the public (or *privatized public*) airwaves, Grennan & Sperandio have embarked upon a number of television projects since 2000 that reflect a significant, and logical, evolution of their socially inclusive practice. They developed a pilot for MTV in 2000, *Reanimate*, modeled after their cartoon projects. Although the pilot was not picked up for broadcast on MTV, it did serve as a valuable learning experience about the world of television, which came in useful during their subsequent projects for corporate mass-market media.

In 2001, they received a commission from Channel Four in England to produce a cartoon film for the Christmas period, so Grennan & Sperandio created *The Liquid Pavilion*, which aired to a television audience of 1.4 million viewers across the UK. Not many artists, even within Europe, have had an opportunity to generate new work through the platform of television, and so Grennan & Sperandio deserve particular recognition for their uncanny ability to negotiate between the cultural spheres of progressive–art making and the popular culture of television.

In 2001 and 2003, they developed two other pilots for MTV (*bloid!* and *Drop It*), which were not picked up for serial production and distribution. Undeterred, they began to develop another idea for a television series, and in early 2005, they commenced production of the first reality-based series made in and about the art world, *ARTSTAR* (in collaboration with VOOM HD Network and Deitch Projects, New York). Episodes of *ARTSTAR* were in production in New York during late 2005 and early 2006. Essentially, the show functions like an art-world version of *American Idol*. On *ARTSTAR*, emerging or unknown artists are selected by a jury of critics, curators, and other cultural intelligentsia and glitterati. Those chosen then proceed to make work

(individually and collaboratively) under the watchful eye of über–art dealer Jeffrey Deitch. The potential winner (or winners) of *ARTSTAR* has the possibility of being chosen for an exhibition at the gallery, or perhaps even representation. Is this parody, the affirmative injection of art-world culture into the ideology of popular culture (a direction that emerged in the 1980s), or some new kind of trans-cultural articulation? Perhaps *ARTSTAR* indicates a unique fusion of media collusion and media criticality, wherein the artists are now offering a reflexive look at the context of the art world through the commonplace language of television? At the very least, Grennan & Sperandio's work is triggering these questions, which is a significant accomplishment in its own right. *ARTSTAR* began broadcasting in June 2006.

Yet Grennan & Sperandio were not quite finished collaborating with cultural institutions. For example, their book *Energy*, which was produced for the Livesey Museum for Children, is one of their most visually sophisticated, intricately narrative, and socially diverse comic-book publications. It was published in the fall of 2004 in conjunction with a museum installation that extended through the summer of 2005, and it features "[t]he hidden energies in daily life by the people of Southwark, London, England." In early 2005, Grennan & Sperandio inaugurated *Soy Madrid*, a work created for "Madrid Abierto," an urban-based, public art exhibition in Spain. Using the same method they employed in earlier projects such as *The Invisible City*, their *Soy Madrid* presents stories told by citizens of Madrid, converted into comic-book form. It was published in weekly installments in the country's largest newspaper, *El Mundo*. Five of the drawings are to be displayed in one hundred locations throughout the city's Metro system, allowing citizens' stories to be injected into the circulatory system of Madrid.

By acting as facilitators of, and interlocutors for, people's desires (both subliminal and explicit) to project their life-narratives back into the generalized social flow, Grennan & Sperandio have given art a unique kind of social agency and new communicative functionality. Their endeavor is contingent upon the participation of others, and therefore their practice is fundamentally collective, participatory, responsive, and even editorial in character. Authorship is predicated upon establishing a network of collaborative partnerships with institutions, people, constituencies, and media entities, and so their practice, perhaps more so than any artist that I am familiar with, is profoundly trans-disciplinary and cross-cultural. And the accessibility of their cartoon-inflected visual language is effectively balanced with a linguistic sophistication so that their comic-book publications succeed in appealing to a wide range of generations and readerships.

To their credit, Grennan & Sperandio never appear to be promoting particular ideological principles or political values. Rather, their project may be a quite persuasive argument for socially engaged cultural work that is not dependent upon some neo-utopian notion of emancipation, or worn out models of so-called political art practice. On a basic level, believe it or not, Grennan & Sperandio's projects have allowed the people with whom they've collaborated an opportunity to look at themselves, and the context of their lives, in a new way; by extension, the projects have spotlighted these ordinary (or not so ordinary) realities.

One could refer to Grennan & Sperandio as *ironic positivists*, who have always insisted that irony, humor, healthy skepticism, and serious social engagement are not necessarily strange bedfellows, or contradictory or irreconcilable attitudes, but necessary ingredients for a new model of communication across real and perceived cultural boundaries and hierarchies. Although they poke fun at themselves and parody the occasionally self-important attitude of the international art world, they remain committed to giving others a voice—without making a fetish of, or patronizing, people who may come from different backgrounds and have different perspectives. Grennan & Sperandio are generous and respectful to a fault, and they are daring enough to mix intellectual rigor with quotidian taste in order to forge a new kind of aesthetic experience. It is a partnership born of commitments to social entertainment and social inquiry, in equal measure.

Kristina
with Sim
and Chr

KRISTINA OLSON: Aspects of your graphic work make it look like it was produced by an untrained teenager for a low-end zine, and yet you guys were seriously art-schooled. How would you describe the look of your work?

CHRISTOPHER SPERANDIO: Our work was described by Gary Groth, publisher of Fantagraphics Books, as technocratic woodcuts. I like that description. When we first began to make drawings, we were quite deliberate about what the drawings should do—how they should function. I don't know if the same can be said for most artists who draw from "the heart." We picked comics apart, making decisions about the elements that we'd adopt. Given our collaborative relationship, we created a style that, while distinctive, is generic enough that either of us could pick up on a page or a project where the other left off. Our work is constructed. Elements are tools in a toolbox. That approach of "choice" is a schooled approach.

SIMON GRENNAN: To skew that question a little, it's been said that our graphics look like cartoons made by artists, which I think is a more interesting, related idea. In thinking about our graphic style, we consciously avoid any attempt to be led by the newest technology, which is a definition of sophistication in any field. It's partly an accessibility thing. Our graphic style has a slightly "left-behind" look, which we like to read as available. It's meant to look like anyone could do it. It's meant to have an unspectacular, friendly look. This is easy to achieve—we only use off-the-shelf technology, car aerosol can rather than motor shop air gun—but we are also conscious of messing with that, so that we make use of low- and middle-end graphics technology in ways that are maybe not so usual. It's a classic art-school methodology.

KO: Can you say something about your stylistic influences? What informs the Kartoon Kings' style?

SG: There's been a lot of talk of nostalgia in relation to our style, which I've never thought was on-the-button. Although we find old visual models creeping into things, our approach is much more to frame a set of visual responses to a current situation. The retro thing just shuts situations down. It's repetition, even if it's ironical, and that conforms to a law of diminishing returns. It's dull. When we combine the low- and

middle-tech methods we use with a straight response to a set of people or a situation, then what comes out the other end takes on an amateur look. We continue to use these methods because of that—we like to go into a situation, use a set of tools, and come out with the work. ABC working, you could call it. It's the way of the enthusiast, the method of the non-professional. You don't get *The Incredibles* by working like this, and amen to that. This year's cutting edge is next year's plodding plopper.

CS: We're not comic artists by training, and I think that it shows in unexpected ways. Although we've had the Fantagraphics Books imprint on many of our books, we've always eschewed identification with the type of comic-book artist that they tend to promote. "Indie" comic artists are primarily a sort of self-absorbed, navel-gazing, and smug citizens of some "counter culture" or other. The creators of those comics, and to a much greater extent, their fans, turn out to be just as repressive and narrow about what constitutes quality as the "mainstream" culture that they reject. By comparison, I'd say our style is based in a real DIY [do-it-yourself] ethos. We decided that comics would be the right delivery agent for our ideas and set about building our own. This process has yielded a singular quality that's impossible to name at first blush. Most comics, you look at it and you move on. If there is a distinction in our work, it's that it sows doubt. When you look at our work, it's looking back at you.

KO: You have strong opinions about art-world demographics. Who is the audience for your work? How targeted is it?

SG: We attempt to make a connection between our graphic style and a specific set of ideas. These ideas are, in no particular order: (1) the good reader, (2) multiple originals, (3) collaborative making, (4) distribution makes meaning, (5) give, don't sell, (6) learn, don't teach, (7) entertainment is uneasy.

Our graphic style could be described in a parallel list: (1) common denominator, (2) use it at home, (3) working for a living, (4) everyone can get one, (5) value lies in the heart, (6) beauty is always a lie, (7) fun is just fun.

So when it comes to questions of audience, our style visualizes a place which is both familiar and didactic. But this didacticism isn't about democracy, socialism, unionization, or whatever—things that have been tossed at our work in the past. Audience-wise, there's only one question: what can we tell each other about daily life? Style-wise, our style shows what the question looks like to us. It's simple. Folks are often puzzled by the idea of "multiple originals" and the idea that "distribution makes meaning." For us, these ideas are not so much articles of faith, they are facts of life. This has nothing to do with Walter Benjamin, whose critique (for us) is a perspicacious tool from the past. We don't position ourselves in relation to production and consumption; we are defined by them. It seems strange, almost childish, to me that folks continue to think that they live independent of mass production, global distribution, and the political imperatives that these things create. This is our world and some of it we like.

CS: Ultimately, the audience is a function of the distribution of the books. The complexity of the work, how it's made, and who it's for tend not to survive long outside of the circles that the work is made for. Assume that Grennan's list is accurate. Our work, as contemporary art, also functions poorly as contemporary art, given that most of the items on Grennan's list run in direct opposition to the values of the contemporary international marketplace. So, we're sort of self-sabotaging, which I like.

KO: A lot of artists are producing impermanent work today. Some feel this is simply part of the reality of our cultural context, a natural outgrowth of working in intangible, digital media; some have expressed the desire not to be co-opted by the art market that motivated so many artists in the '60s. What are the Kartoon Kings' reasons for dealing in ephemera?

SG: When Claudius Drusus Nero Germanicus left his histories lying around, it was because he knew that they had more chance of making it through than if he took pains to preserve them. History had taught this to him, he wrote. Everything is ephemera. The question ties together commodification and an idea of permanence, and for us they aren't related at all. We don't have any trouble with commodities, and we don't see strategies to ignore or circumvent the art-commodity market as ways to dodge permanence by making things that dealers find hard to sell. The art-commodity market is small. The world is big. Nothing endures. Not even unique and valuable art. Not even our love and pain.

CS: For me, it's more grounded in where I'm from and who I am now. To be a well-collected contemporary artist, you have to be motivated not by ideals but a desire to climb the social ladder. It was like that in the time of Proust and it's like that now. I'm simply not interested in the same things that the collecting class is interested in. This is an informed choice that I made regarding how I want to spend my days. I recently had an encounter with a moderately well-known graffiti artist, someone who grew up "on the streets" and whose work, by very definition, should be the most fugitive. I've never met an artist more concerned about his status as an artist. The market has a gravity and can crush and distort artists. I'm happy to be out of the direct gaze of the Gorgon. Ephemera is a polished shield.

KO: It's probably fair to say you've often had a prickly relationship with the art world as well as with academia. What is your sense of the separation of fine art and pop culture in terms of your work, especially your graphic work? How do art schools help or hinder these perceptions?

SG: We don't have a prickly relationship with anyone, really. We don't have unique things to sell, so the kind of market that sells unique things doesn't have a place for us. Seems fair enough. We like giving lots of stuff away . . .

CS: Simon can say that because he lives in a five-hundred-year-old house in the country. I've been in New York for the past fifteen years, and I do find the art world to be offensive. However, I don't think the art world is too concerned about my reservations. Coming from a small coal-mining town and going straight into the West Virginia University art

program, it was only in graduate school in Chicago when I first began to get an inkling of what it was all about. By the time I realized that what the art world had to offer is something I didn't want, it was too late. Maybe it's me who's prickly and the art establishment is OK. Who's to say?

KO: Do you see your current work on television pilots, such as *ARTSTAR*, as a natural outgrowth of the graphic publications?

SG: We've made a number of animated films, both before *ARTSTAR* and after.

CS: In the sense that television is a great distribution point, yes. Our interest in distribution has grown to supplant some of our earlier ideas about authorship and how art is made and who it's for. The television work, for the most part, is an experiment. It's a separate vernacular, with its own peculiar requirements. It's really more of a different and simultaneous field of inquiry. Our books are still made for a mostly local audience and based in a sense of place and community. TV is much more autocratic, good at communicating across distances but not really responsive to local needs. Of course, distributed electronic culture like television is in a crisis now, so who knows?

KO: Speaking of distances, you two have managed to make across-the-ocean collaborative art for a lot of years now. Can you offer a prediction about what the future holds for the Kartoon Kings?

SG: We're always working on a record album. Twelve songs created when someone presses "play" on their CD player.

CS: Seriously, we don't know. Books, films, TV shows, a major retrospective, or crossing the street against the light and getting smacked by the number fifty-three bus. I hear the Internet is big now. Maybe we'll give that a go.

Grennan & Sperandio:
Outtakes from the Collective

by Paul Krainak

"Lighter-than-air . . . punchy, bottom-heavy bounce . . . gritty, punk-addled energy . . . involuntary pelvic gyrations. . . rolling beat . . . abstract mayhem . . . zoned-out grooves." This novel fusion of street colloquialisms and straight description conjure an event at PS1 in an episode of Grennan & Sperandio's *Modern Masters*. Commissioned by the Museum of Modern Art MoMA in conjunction with DC Comics, the edition was jammed with short, illustrated accounts of MoMA and PS1 gleaned from interviews with patrons, staff, administrators, and even a couple of curators. Some stories were critical of the institution, others complimentary. Some were self-deprecating, others narcissistic. All were graphically evocative of the great American special-edition superhero comic the artists have exploited to connect the dots between the seat of the culturally privileged and the land of the culturally typecast.

Usually the artists are invited by an organization or institution to produce a book, exhibition, or billboard project engaging one of the client's constituencies. Museums in the last decade have come under increased pressure by government agencies, who partially fund them, to be more inclusive. This has dovetailed conveniently with a few artists' desires to perform certain kinds of interventions into museum collections and procedures, to consider issues of curatorial authority and ideological representation and display—longstanding concerns of Grennan & Sperandio. In addition, the evolution of museums from places of research and conservation to centers of production and entertainment has been problematic for many in the academic and professional art communities, but it has provided fertile ground for young artists who want to blur the lines between popular culture and fine art. Cultural studies programs intruding on the once jealously guarded territories of art history and connoisseurship have fueled the reconsideration of artists' relationships to the museum, the curator, the administrator, and the collector. Grennan & Sperandio produce their projects with a keen eye toward a radically different discourse with respect to audience, market economy, and influence in the arts.

In approaching and representing members of any community, the artists assume a certain ethnographic detachment as well as a sense of humor. Research by the artists is unobtrusive, and stories for the books are solicited by either a blanket call through local media or

through demographic selection (i.e. a random sampling of individuals of different races, classes, occupations, and ages in a given region). Each project is also steered by the questions the artists initially pose to participants. Often their questions have to do with simply asking participants to relate an important event in their lives or describe a career goal. The questions may be oriented toward such issues as regional histories, communities, or economies. Whether stories are gathered through the artists' demographically based selection process or through personal ads, they are remarkably guileless, anecdotal, idiosyncratic, and ironic.

There is no effort to exaggerate or embellish language, but each account in the artists' shrewdly conceived and brilliantly colored book jackets has its own raking-headlined stories. "Ring of Shadows" and "Coin in the Dirt" are from Grennan & Sperandio's *Ghost on the Stair and Other Stories*, in which people from the industrial north of England chronicle uncanny "true stories." The recollections aren't earth-shattering, but the faux-epic context gives them power that is inexplicably both tongue-in-cheek and corroborating. In another comic-book project, *Invisible City*, graveyard-shift workers suffer their own regret, rise to personal challenges, or struggle with feelings of anxiety—ordinary experiences that characters in the book alternately act out and turn to the reader to explain. Grennan & Sperandio depict both the story and the telling of the story, a literary device one would expect in a far more sophisticated genre. Readers have the impression that they are being taken into confidence. Among numerous instances of discouraging political and economic conditions in the most chilling of post-industrial environments, the narratives never fail to provide surprising glimpses of individual interior lives. No more adorned than tavern yarns, their final forms are like outtakes from animated cinema verité. Like first encounters with complete strangers, they capture part of the deferred desire, distractedness, and distance that characterizes so much of contemporary urban life in Britain and the United States, where most of the stories are set.

Grennan & Sperandio bestride the same shifting ground that underlies the most striking of post-conceptual art. They produce collaborative projects and public works illustrating the inevitable and the inevitably conflicted relationship between haute culture, underserved audiences, and popular media. Dispensing with preconceived notions of the role of artists in Western society, they avoid the tattered studio label of "alternative media." Instead they direct and employ the animator's craft as they do the editor's, the designer's, or the printer's, and they amplify the comic / graphic-novel format to an organ of social record and aesthetic controversy. Dispatching an outsider vehicle dripping with lowbrow sentiment, they insert it into a highbrow milieu and fill it with curious fragments of plain speech. Tabloid layouts, bracketed thought balloons, and heavily outlined figures tease dramatic development and promise narrative closure. But there is none, either for the casual reader who likes culty illustrations or the art browser expecting a send-up of high culture. The digitalized images and episodic texts, which resist academic authority and flex pop-culture muscle, are reminiscent of interloper tactics stemming from early Dada to late Fluxus. Exploiting

pulp advertising design and raucous comic graphics, they breathe new life into the found object endeavor to desacralize the museum.

The artists' motivations are deceptively simple. Take one popular platform for grand themes, glamour, and escapism, meld it with a more privileged venue, and dissolve the pretense of difference between the desires of one class and the values of another. Then slash and burn through decades of pop-art vernacular and give their audience an essentially modern opportunity to see themselves in an artwork and interrogate that identity. Like the memory of the PS1 rave, the books are stripped-down bare essentials—the ebbing and flowing of raw, sometimes banal, experience. The original, defiant idea of the modern still flourishes in their ordinary subjects, real matter, and one-on-one relationships. Grennan & Sperandio lay claim to the present by insisting that any one of their narrators comes in as loud and clear as anyone else on the food chain.

One can't overestimate the sheer effrontery and power of a debased pop-culture standard. The comic is a sixty-year-old medium evolved from a century of posters and broadside leaflets that in turn affected another century of pulp fiction, advertising, and hundreds of literary and cinematic works all etched into a collective conception of the West. Most of Pop art and neo-Dada is indebted to the comic industry, but until relatively recently, DC Comics or Fantagraphics, two of the artists' biggest publishers, remained at arms length from the art world.

The best comics are Joycean, with excruciating detail disjointedly coded and alternately lurid and commonplace. Nearly every cell in the narrative has equal visual power and persuasion, not unlike any significant readerly text, film montage, or collaged painting. Immerse yourself anywhere in any book. If beginnings and endings were rearranged, a reader would still be struck by the formal rhythm of shapes and signs that explode across the page. Begin a story in the middle with its motion already at full bore, and plug yourself in. It's like any normal day in the turmoil of popular media. Cultural consensus is elusive. You have to triangulate one from the collaborative record. Your assumptions are thwarted as you work out the action and get snared in the fragmented signs and the idiomatic patterns of language. It feels real because it's a work in progress. Instead of coherent narratives, the reader arrives at a stealth critique of the West where authorities are often implicated in a vulgar mismanagement of culture. In these masquerades of popular fiction, social hierarchies are contested with farce. The cartoon cell shares one of the tragedies of the modern: within its cool, hardedge logic dwells a surfeit of self-consciousness, doubt, resentment, escapism, and boredom. These ordinary dramas elicited over the last fifteen years give probity to expressions of confidence that young people feel in their own abilities to navigate through global culture's residue of cheap thrills and false idols.

For the most part, Grennan & Sperandio leave themselves out of their books, acknowledging that contemporary artists, even those considered activists, represent a world that has not been generous to the working-class people who are often their subjects. The practice of collecting and sorting through unadulterated stories and substituting

them for canonical certainties and stylish discourses motivates the artists' collaborations. Progressive artists rarely provide real bridges between their profession and other workers or to disenfranchised publics. The artists think that what's worth putting on the table of the institution are voices that are not predetermined by official culture or the mainstream media even if they seem naïve or, at first glance, irrelevant. Co-opting a venue that accepts a wider range of shared subjects and is ingrained in the unofficial experience of modernity is both radical and pleasurable. This work is an ongoing process of scrutinizing images of our institutions and ourselves. It's a hybrid of art and popular culture, and it ameliorates class divisions with respect to the thorny issue of taste. The work is full of droll observations of enduring the last gasps of modernity and is profoundly dismissive of the prevailing reciprocity of cultural power and glamour.

The anecdote has been useful in subverting the overarching themes and purist directives of high modernism. An anecdotal comprehension of the world is a different kind of truth telling that makes no claims to logic and preeminence. It conflicts with theory and is antithetical to style. It's antagonistic to authority but the friend of authenticity. What it lacks in hard evidence, it makes up for in probability. It's the quick-witted, sure-footed expression of the ordinary, the acquiring of significance of the overlooked and the unofficial—acknowledging that which is unnamed. It's the search for pattern emerging in the extraordinary occasion of one's being. The memoir, by extension, has taken on new significance in a culture whose identities have been dishonored by economic malfeasance, ecological unaccountability, and aesthetic hyperbole. What we miss in official histories we can discover in individual memory. It's direct and confessional. All objective data is replaced by the foibles of human motivations, mental faculties, and the fog of experience. Grennan & Sperandio employ the anecdote to a troubling and enduring trait of late modernism—the persistent inability for contemporary art to signify outside a proscribed discourse. Due partially to their efforts, the barriers between institutions, classes, and media have become a significant locus of artistic investigation, and as a result they are considerably more benign, porous, comprehensible, and a hell of a lot more fun.

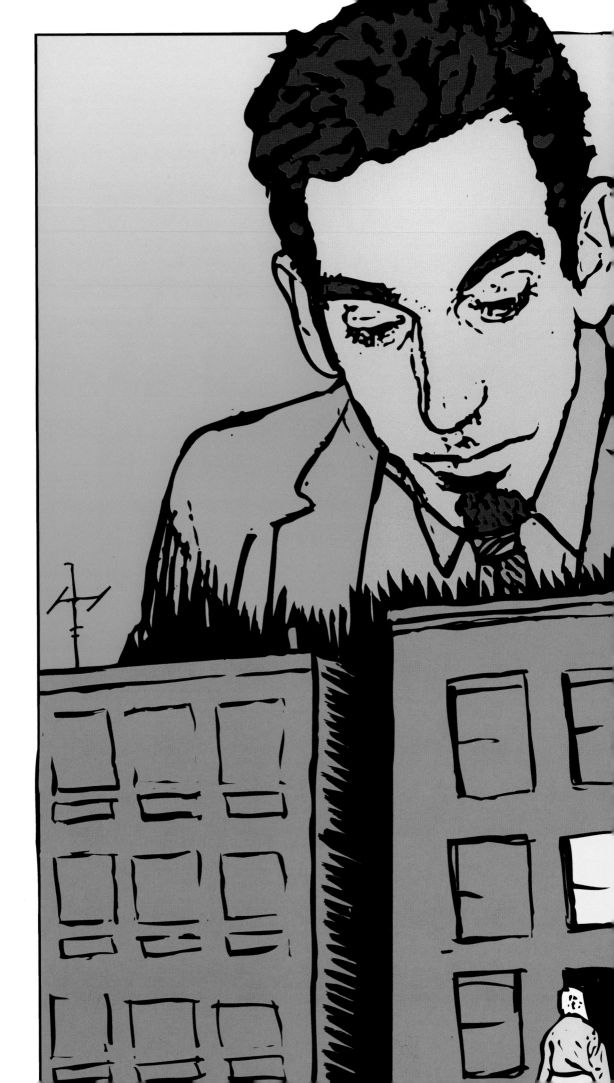

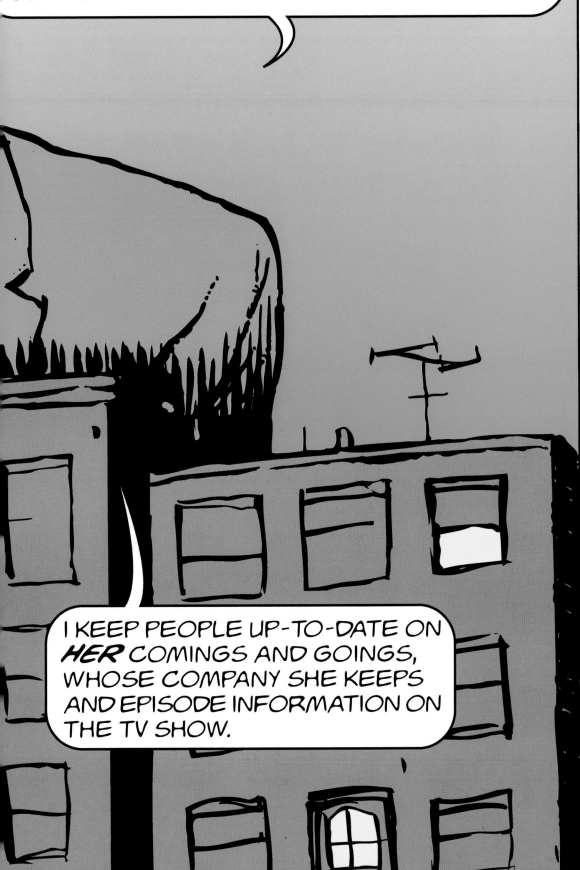

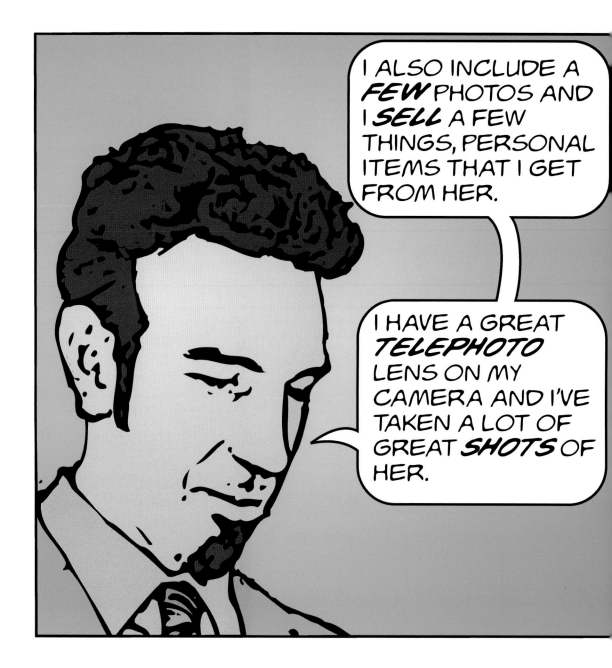

I ALSO INCLUDE A *FEW* PHOTOS AND I *SELL* A FEW THINGS, PERSONAL ITEMS THAT I GET FROM HER.

I HAVE A GREAT *TELEPHOTO* LENS ON MY CAMERA AND I'VE TAKEN A LOT OF GREAT *SHOTS* OF HER.

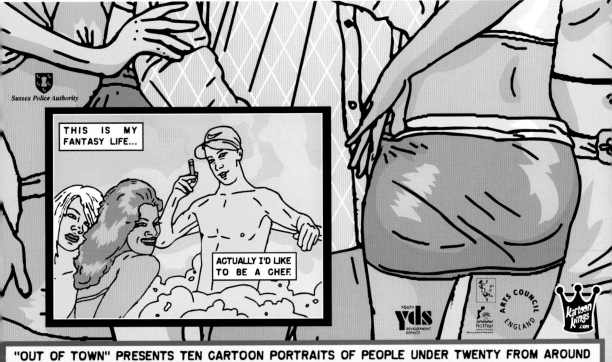

OVERTURE, CU
THIS IS IT, THE N
NO MORÉ REHE
NURSING OUR I
WE KNOW EVERY

overture, curtain, lig
this is it, to hit the heights
and, o what heights we'll hit
on with the show, this is it

**Tonight What Heights We'll Hit
On With The Show, This Is It**

* * * * * *
BUGS BUNNY OVERTURE (THIS IS IT)
by j. livingston and m. david

AaBbCcD

RTAIN, LIGHTS
GHT OF NIGHTS
RSING &
ARTS
PART BY HEART
s

Bit o'Hunnie
fGgHhIiJjKkLlMmNnOoPpQqRrSsTtUuVvWwXxYyZz!*

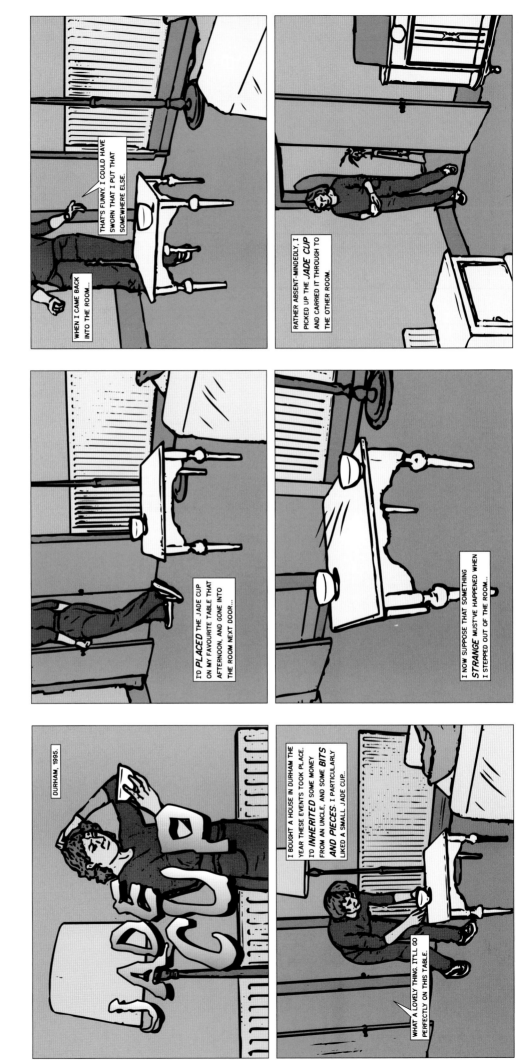

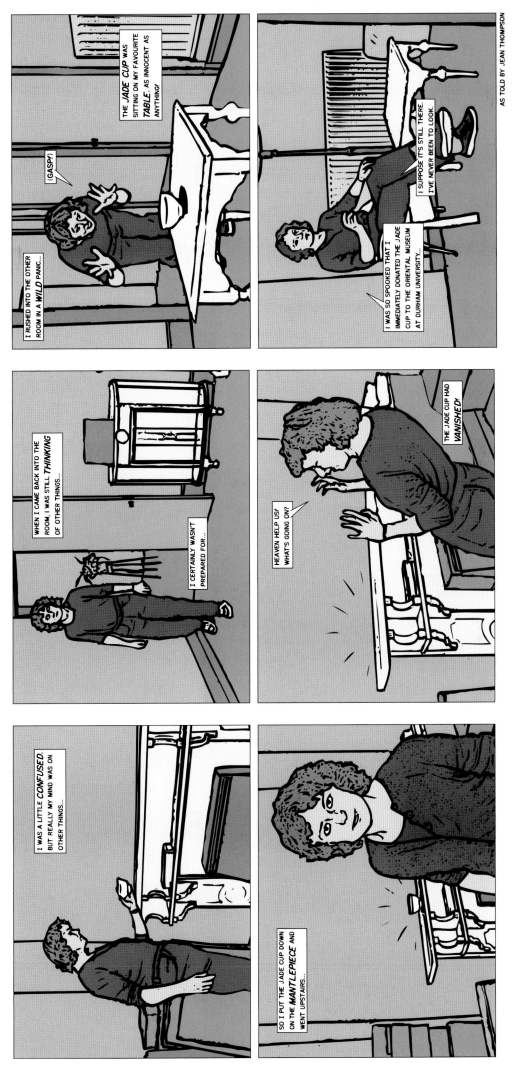

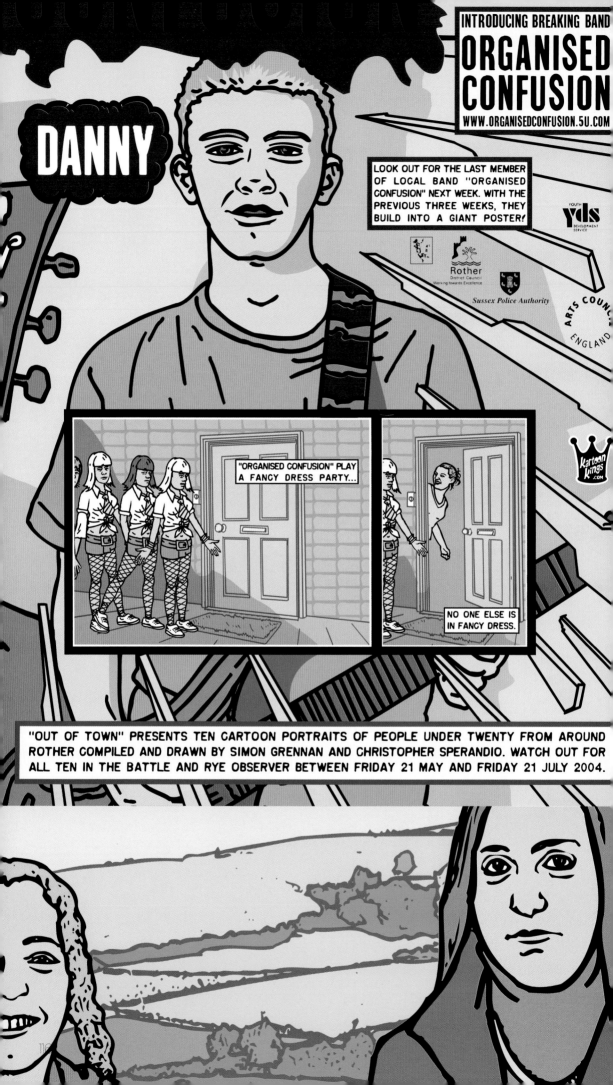

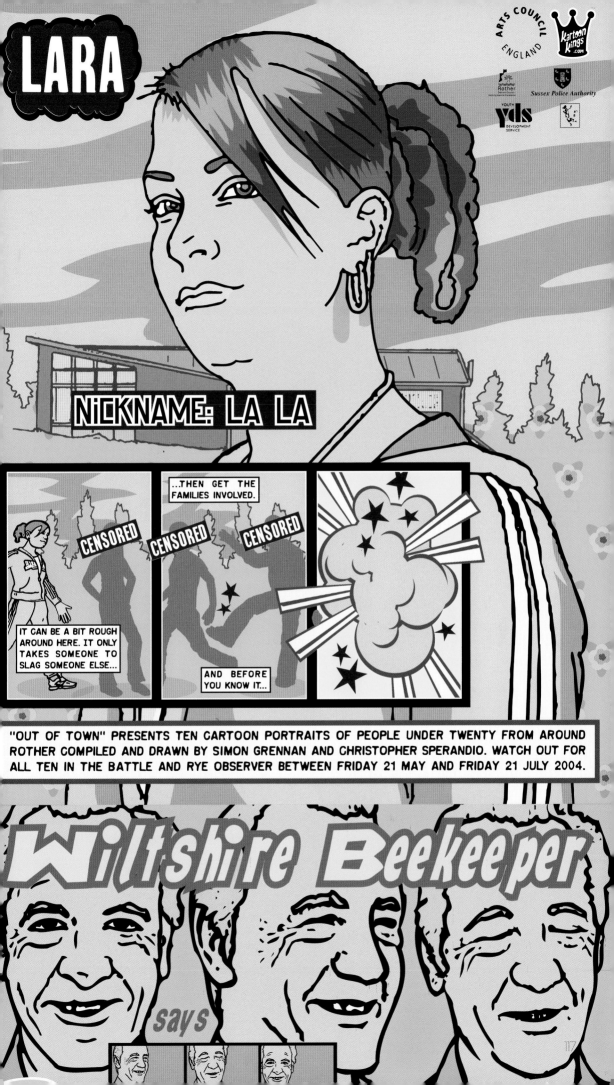

LARA

NICKNAME: LA LA

IT CAN BE A BIT ROUGH AROUND HERE. IT ONLY TAKES SOMEONE TO SLAG SOMEONE ELSE...

...THEN GET THE FAMILIES INVOLVED.

AND BEFORE YOU KNOW IT...

CENSORED CENSORED CENSORED

"OUT OF TOWN" PRESENTS TEN CARTOON PORTRAITS OF PEOPLE UNDER TWENTY FROM AROUND ROTHER COMPILED AND DRAWN BY SIMON GRENNAN AND CHRISTOPHER SPERANDIO. WATCH OUT FOR ALL TEN IN THE BATTLE AND RYE OBSERVER BETWEEN FRIDAY 21 MAY AND FRIDAY 21 JULY 2004.

Wiltshire Beekeeper

says

I DECIDED WHILE GETTING DRUNK THAT IF THE WALLET STAYED DISAPPEARED I WOULD RESUME *NUDE-Y* BAR WORK BECAUSE I HAD TO...

BUT IF SOMEONE RETURNED IT, I WOULD *NEVER* DO THAT WORK AGAIN.

ld flaps

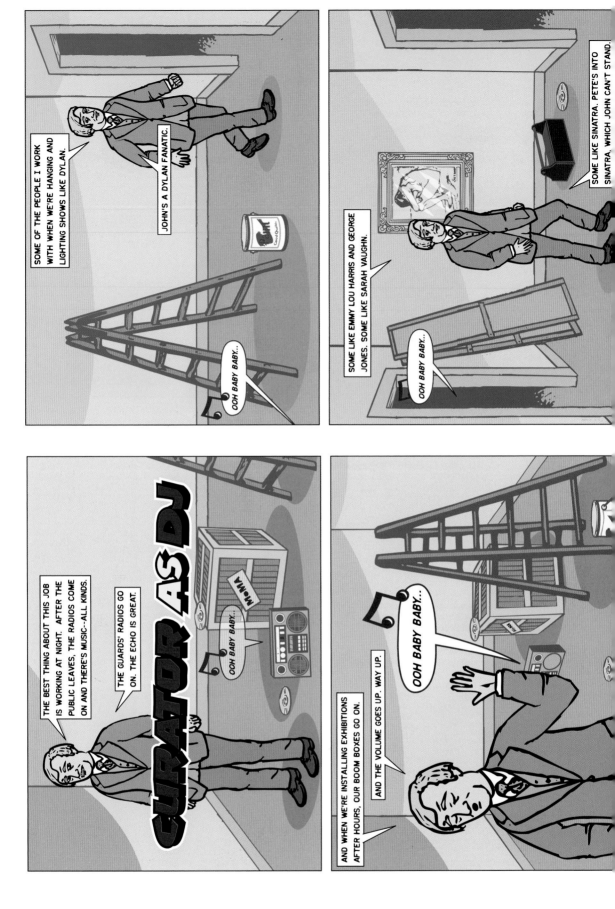

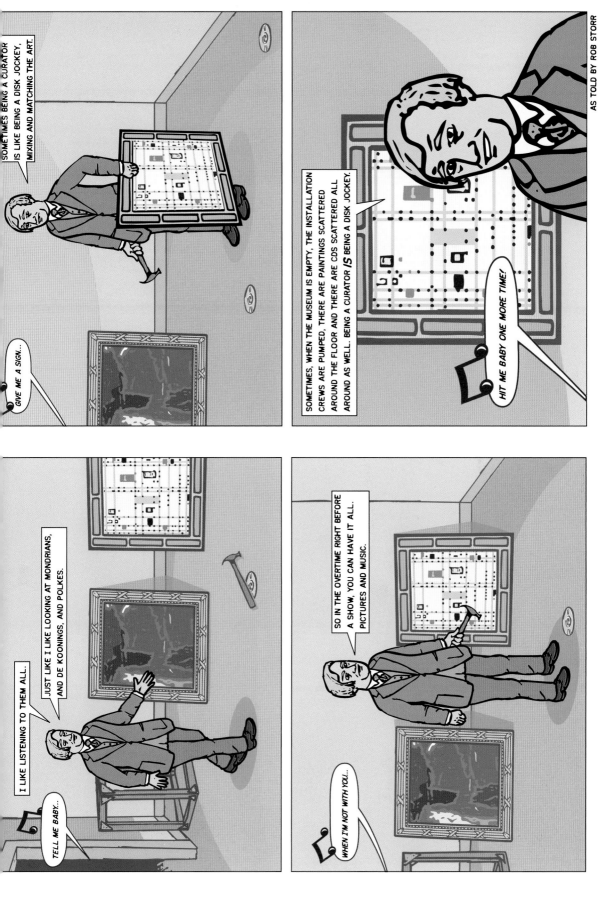

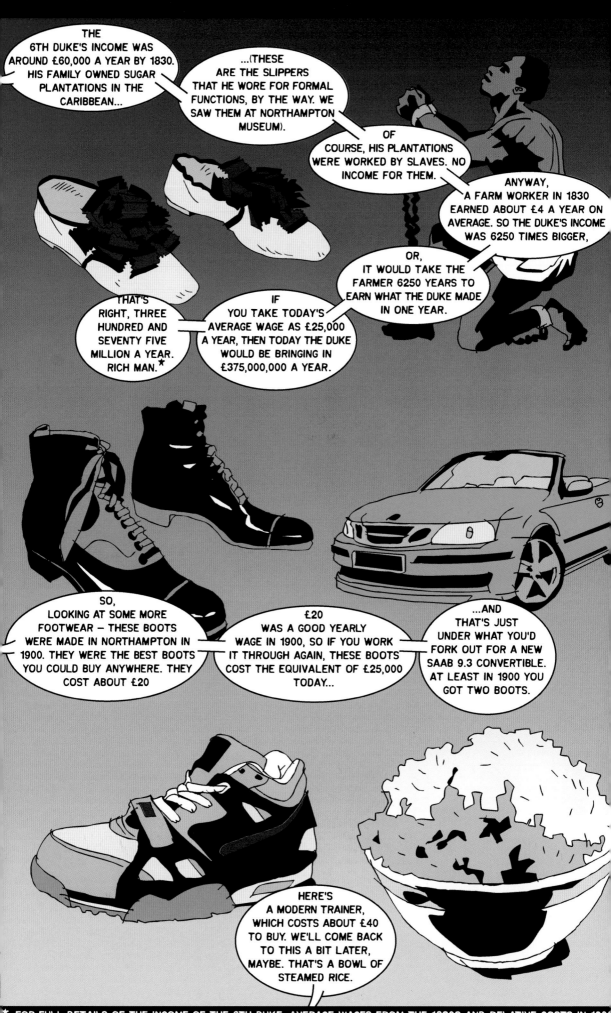

KING AT NIGHT I HAVE DISCOVERED THAT THE
S ARE *BETTER* THAN SOME OF HUMAN SOCIETY.
EY CAN BE REALLY GOOD LISTENERS AT TIMES.

HER THING...

2007

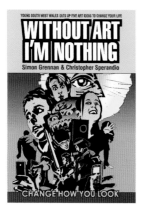

Without Art I'm Nothing, one of two 24-page comic books made in collaboration with seventy teenagers from south Wales, looking at five philosophical ideas underpinning contemporary art. Audiences Wales, Cardiff, Wales, 2007

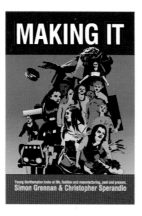

Making It, a 24-page comic book in an edition of 11,000, made in collaboration with Northampton Youth Forum. Northampton Museum, Northampton, England 2007

2006

The Conversationalists, a 48-page book in an edition of 7000 commemorating conversations had by Berwick townspeople. English Heritage, Berwick-upon-Tweed, England, 2006

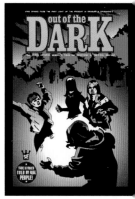

Out of the Dark, a 24-page comic book in an edition of 10,000, featuring 24 local teenagers. English Heritage, Thetford, England 2006

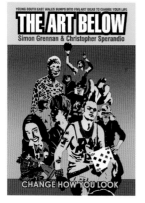

The Art Below, one of two 24-page comic books made in collaboration with seventy teenagers from south Wales, looking at five philosophical ideas underpinning contemporary art. Audiences Wales, Cardiff, Wales, 2007

Street Dreams, a series of three painted out-door installations. Land Securities, Corby, England, 2007

Back Then Right Now, a 24-page book for five public attractions in Hampshire, in an edition of 25,000. AMH, Winchester, England, 2006

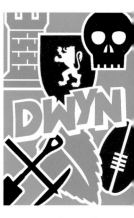

Dwyn, a card game for Wales in an edition of 2,000. Chapter Arts Centre, Cardiff, Wales, 2006

2005

The Greatest Gift, a painted installation of favorite Christmas presents. Queen's Hall, Hexham, England, 2005

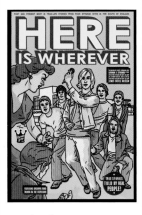

Here is Wherever, a 24-page comic book for five galleries in the South East of England, made in collaboration with teenagers. SAM, Sussex, England, 2005

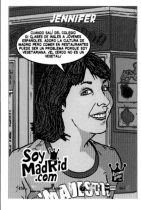

Soy Madrid, 18 full-page tabloid color narratives published every weekday in February, 2005, plus 5 subway posters across the Madrid public transit system. El Mundo newspaper and Madrid Abierto, Madrid, Spain, 2005

2004

Spacewalk, a five-minute animated film made in collaboration with skateboarders. The Hayward Gallery, London, England, 2004

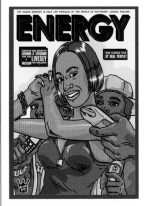

Energy, a 24-page comic book looking at life in the London Borough of Southwark. Livesey Museum, London, England, 2004

Out of Town, ten full page tabloid color narratives, appearing each week between May and July. Battle and Rye Observer Newspaper, Rother, England, 2004

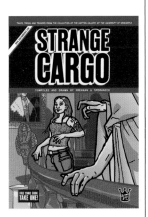

Strange Cargo, an 80,000 square foot installation plus an accompanying 24-page collections-based comic book. The Hatton Gallery, Newcastle-upon-Tyne, England, 2004

Stadium Extra, a series of eight portraits of local people painted into storefront windows. Wembly Borough Council, England, 2004.

2003

Heaven Can't Wait, a painted installation. De La Warr Pavilion, Bexhill-on-Sea, England, 2003

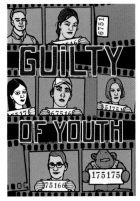

Guilty of Youth, two posters for sites around town, made with fifteen local youths. Rother District Council, Rother, England, 2003

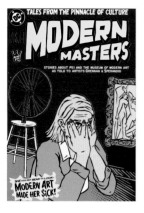

Modern Masters, a 48-page book telling stories of MoMA and PS1 employees and visitors. Sold from within an installation at PS1. DC Comics, Museum of Modern Art, and PS1, New York, USA, 2002

Glazed Looks, eight portraits of residents painted directly into shop windows. Canterbury City Council, Canterbury, England, 2002

Tales of the River, a regional newspaper-based project. Hull Time Based Arts, Hull, England, 2002

Danish Pastries, a gallery installation featuring a Danish language animated film (with English subtitles). Aarhus Kuntsmuseum, Aarhus, Denmark, 2001

Shifting Gear, a residency at the first Wal-Mart in England yields a customized double-decker bus and an in-store exhibition of giant billboards and featuring stories as told by employees and neighbors. ASDA/Wal-Mart, Swindon, England, 2002

Young English, 10 billboards made for the A-5 motorway in conjunction with area young people, Staffordshire County Council, Stafford, England, 2002

Talk of the Town, traveling exhibition with new murals and a regional newspaper project. The Gallery, Stratford-upon-Avon, England, 2002

16/25, a three-gallery survey of the graphic work of Grennan & Sperandio along with a newly commissioned animated film featuring self-described "townies." Gallery of Modern Art, Glasgow, Scotland, traveling to Stratford, England, 2001

What in the World? a collections-based, 24-page comic book for nine museums. Manchester Art Gallery and eight additional museums, Manchester, England, 2002

Belfast Sky, a painted gallery installation featuring landscape murals. Catalyst Arts, Belfast, Northern Ireland, 2002

Don't Get Me Started, a year-long community-based web site project depicting gripes. Turnpike Gallery, Leigh, England, 2001

The Liquid Pavilion, a commissioned animated short based on an original script. Channel Four, England, 2001

Nearly There, an artists' residency yielding a multimedia gallery installation. Yerba Buena Center for the Arts, San Francisco, USA, 2000

Preston, an animated film retelling stories from around town. Harris Museum, England, 1999

Trading Tales, a series of eight strip cartoons for the Cardiff Journal made in collaboration with small traders from the city centre. Centre for Visual Arts, Cardiff, Wales, 1999

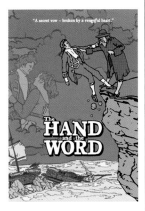

The Hand and the Word, a residency with The Players, a community theater group, yielding an animated film and web site. BALTIC Centre for Contemporary Art and Tyne Tees Television, Gateshead, England, 2001

Nurses's Tale, a hospital residency yielding a 24-page comic book sold in the Hospital gift shop. Saint Leonard's Primary Care Trust, Hastings, England, 2000

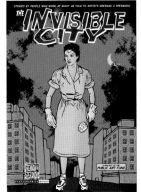

The Invisible City, featuring stories told by night workers yielding advertisements covering 1/4 of the NYC Subway and a free 24-page comic book. Public Art Fund, New York, USA, 1999

Up In The Air, a print installation for the exhibition Up in the Air, Liverpool, England, 2000

Frequent Traveler, four bus advertisements for the Route 12:36 project at the South London Gallery, London, England, 1999

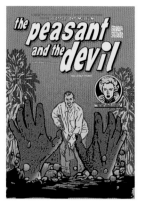

The Peasant and the Devil, a collaboration with Cindy Sherman producing a 24-page comic book and installation. Seattle Art Museum, Seattle, USA, 1998

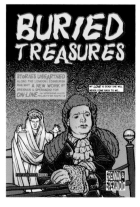

Buried Treasures, a 24-page comic book based around the train serving London and Edinburgh. Stories solicited via in-train magazines and distributed via train platforms. Photo '98 and Impressions Gallery, England, 1998

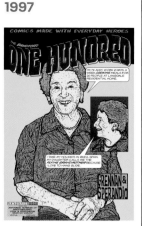

The Bradford 100, a 100-page comic book and gallery installation of digital prints celebrating members of the Bradford community. National Museum of Photography, Film and Television, Bradford 1997

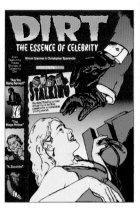

Dirt, a gallery installation featuring this commissioned 24-page comic book presenting stories of brushes with the famous. Museum of Fine Arts, Boston, 1996

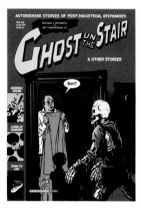

Ghost on the Stair, a 48-page comic presenting stories of the post-industrial North of England. Artranspennine98, 1998

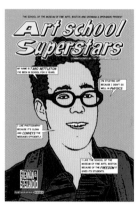

Art School Superstars, interaction with students at the museum school in Boston producing a 24-page comic book. SMFA, Boston, USA, 1998

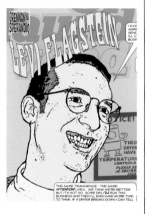

Levi Flagstein a full page in Artforum, Summer 1997, commissioned by American Fine Arts Co, New York, USA.

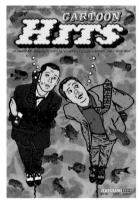

Cartoon Hits, a 36-page comic book featuring stories as told by museum members. Institute of Contemporary Arts, London, England, 1996

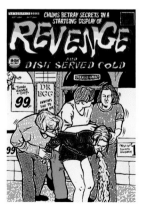

Revenge, a 24-page comic book presenting small stories of revenge in 3-D. IKON Gallery, Birmingham, England, 1998

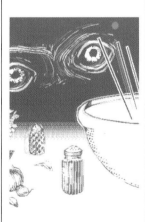

All 'Round Awesome, eight 3D silkscreen prints representing supernatual experiences. Commissioned for the exhibition Traffic at CAPC Musee D'Art Contemporain, Bordeaux, France, 1996.

Trackstar, a painted installation and comic strip commissioned for the a/drift exhibition. Center for Curatorial Studies, Annendale-on-Hudson, USA, 1996

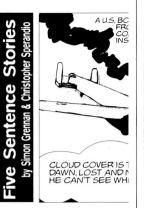

Five Sentence Stories, twelve newspaper comic strips presenting short stories, Salisbury Festival, 1995

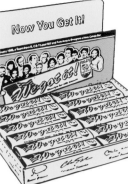

We got it! a collaboration with a unionized chocolate factory yielding a chocolate bar monument to organized labor. 10,000 chocolate bars in point-of-purchase displays and 40 billboards sited in working class neighborhoods. Culture in Action, Sculpture Chicago, USA, 1993

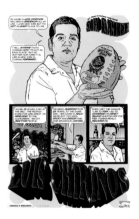

Luis Chirnios, Shopping, a 500-edition poster depicting this SoHo trader. Deitch Projects, New York, USA, 1996

Life in Prison, a 24-page comic book commissioned for the Prison Sentences exhibition, Philadelphia, USA, 1995

Mutant, a 500-edition poster depicting a friend of the artists. Galerie Philippe Rizzo, Paris, France, 1996

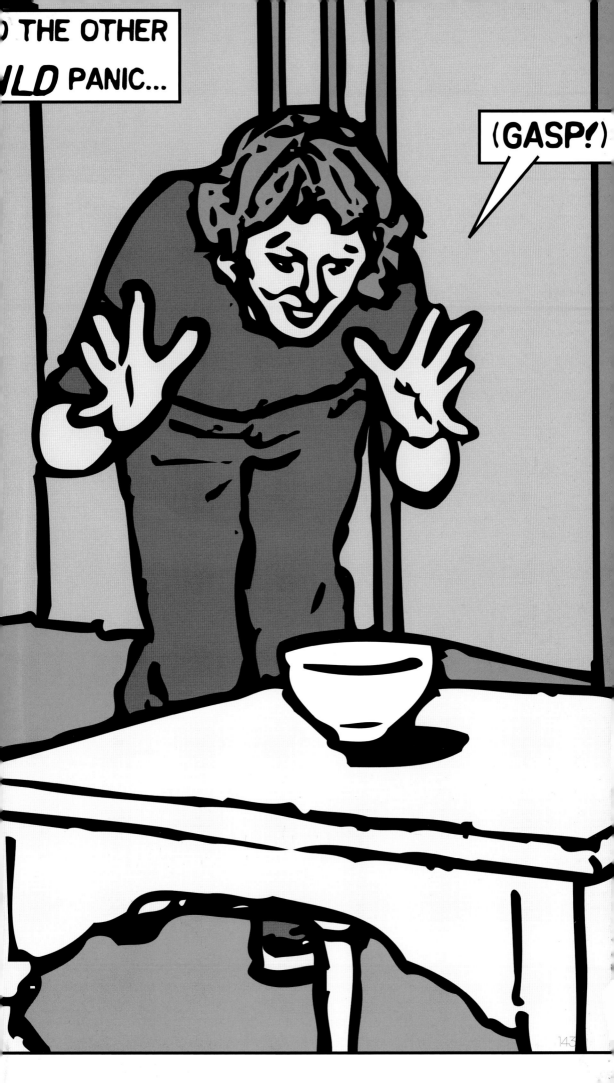